IMAGES
of America
The City of
WAYNE

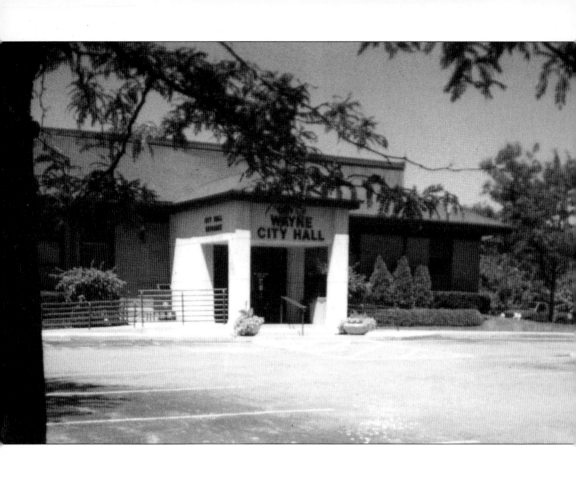

IMAGES
of America
The City of
WAYNE

Valerie Latzman

ARCADIA

Published by Arcadia Publishing,
an imprint of Tempus Publishing, Inc.
Charleston SC, Chicago, Portsmouth NH,
San Francisco

Printed in Great Britain.

Library of Congress Catalog Card Number: 2003108121

For all general information contact Arcadia Publishing at:
Telephone 843-853-2070
Fax 843-853-0044
E-Mail sales@arcadiapublishing.com
For customer service and orders:
Toll-Free 1-888-313-2665

Visit us on the internet at http://www.arcadiapublishing.com

This book is dedicated to my mother, Virginia Presson. Her love of Wayne's history has been life long. Her patience and knowledge have helped many people find their connections to Wayne's past, and in so doing she has helped insure that its history will live on and hopefully be shared with future generations. Her concern extends beyond the story itself to the artifacts, and she has worked for many years as a volunteer and as Wayne Historical Museum Manager to promote preservation and restoration.

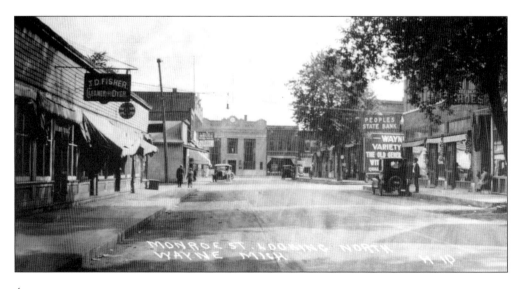

CONTENTS

ACKNOWLEDGMENTS

It's been said that history writes itself, but the living, recording, and imaging of that history belongs to all those along the way whose lives and actions *are* the history. In July of 1956, a group of people from the Wayne area gathered to organize the Greater Wayne Historical Society. Some of these people had lived their whole lives in the vicinity of Wayne while others were relative newcomers. All of them found Wayne to have a rich historic past, a present that would all too soon be history, and a future that would be less without the preservation of records, images, and artifacts that would, with a personal touch, tell Wayne's story of growth, change, and development. Pictured below, from left to right, are those who attended the very first meeting of the Greater Wayne Historical Society: Helen Bird, Estelle Bunting, Marilyn Hogan, Mary Stellwagen, Charles Curtiss, Leurs Beeson (Executive Secretary of the Historical Society of Michigan), P.D. Graham, Leonard Mitz, Elizabeth Stellwagen, Florence Hess, Dr. James Caraway, Thomas Hawley, Clarence English, and Clarence McCarty. Following the example of these individuals, many others have since added to the collections, taken historic pictures of the moment to add to the archive, and very importantly, shared their anecdotal recollections. The list of those who have inspired this book is very specific, but the fear of omitting even one person whose knowledge and enthusiasm has meant so much discourages printing that list.

Special acknowledgments go to the Wayne Historical Museum, Getty Imaging, Time-Life, Inc., the Michigan State Police, DTE, and everyone whose pictures appear on these pages. Also, to Maura Brown and the Arcadia staff who made this an easy and fun project!

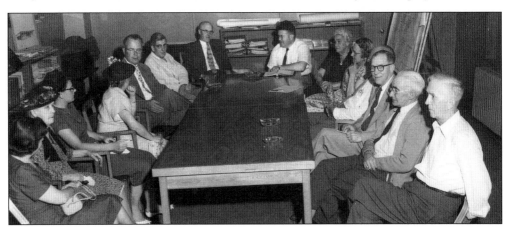

INTRODUCTION

The history of any place is marked not just by the chronological listings of its development but by its people as well. Families who once lived in the Greater Wayne area but who have moved away carry its history with them. New families moving to the six-square-mile City of Wayne contribute to the ongoing saga of a remarkable place.

Located 17 miles west of Detroit, the area was noted for rich farmland, diverse flora and fauna, cranberry marshes, saltwater wells, and a determined and hardy population who decided early on to carve out a prosperous town with opportunity for everyone who was willing and able to contribute to the effort. Education and religion were two of the first and most important focuses of growth. From these institutions sprang much of the community's opportunity for social encounters and entertainment, as well as being a place to dispense the era's version of social service, such as giving food and clothing to the needy and making bandages during the war. Wayne defined itself as a community of conscience by the stand it took on issues national and local. The number of successful individuals nurtured in the area has continued through time to include judges, lawyers, clergymen, a member of the first Great Lakes survey team, a national figure skater, educators, doctors, national news reporters, a state archeologist, major league baseball players, and most importantly, happy, healthy citizens.

Wayne has always had something of an ethnic identity—for a while during the 19th century, it was characterized by the German and Irish families who made up most of its population. After WWII, the African-American population began to grow, and by 2003, Wayne is truly a multiethnic city as evidenced by the Tae Keuk Korean Village, the election of Lebanese born and raised Al Haidous as Mayor, and the inclusion in its citizenry of many nationalities. The fact that there are 24 different languages spoken as first languages in the Wayne-Westland School District (whose name was changed from the Wayne Community School District in 1971) indicates that cultural growth is fully under way.

There have been humorous events and dangerous events and tragedy and joy in Wayne just as in any other community. But the continuity of purpose has managed to take a swampy no-man's-land and turn it into rich farmland, develop it into a fully self sufficient community with business and industry, and help it to survive devastating urban renewal and evolve into an attractive, safe, and welcoming community of the 21st century.

One
GREAT BEGINNINGS

This was the drawing for the Historic Marker placed on the building nearest where Johnson's Tavern stood. Wayne's history is full of life stories of real people who have struggled. They have sometimes failed but more often succeeded. Neighbor has helped neighbor, and a very strong community was built around the need to meet challenges. Strong social and educational values have been responsible for most of the decisions in Wayne's growth. The greatest thing left today that is representative of Wayne's past is the sense of community that propels Wayne forward.

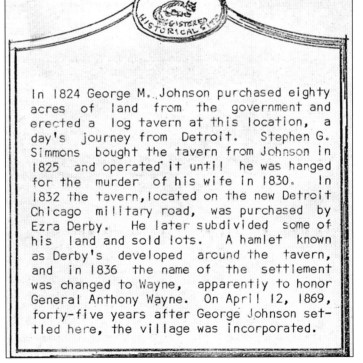

In 1824 George M. Johnson purchased eighty acres of land from the government and erected a log tavern at this location, a day's journey from Detroit. Stephen G. Simmons bought the tavern from Johnson in 1825 and operated it until he was hanged for the murder of his wife in 1830. In 1832 the tavern, located on the new Detroit Chicago military road, was purchased by Ezra Derby. He later subdivided some of his land and sold lots. A hamlet known as Derby's developed around the tavern, and in 1836 the name of the settlement was changed to Wayne, apparently to honor General Anthony Wayne. On April 12, 1869, forty-five years after George Johnson settled here, the village was incorporated.

Ezra Derby helped build the first schoolhouse in Wayne. He first platted the town and for a time it was known as Derby's Corners. He moved around the area over the years but there is still a house in Wayne that was moved to Norris Street and added onto by Ezra Derby. The area is zoned commercial so it is doubtful that it will remain standing much longer.

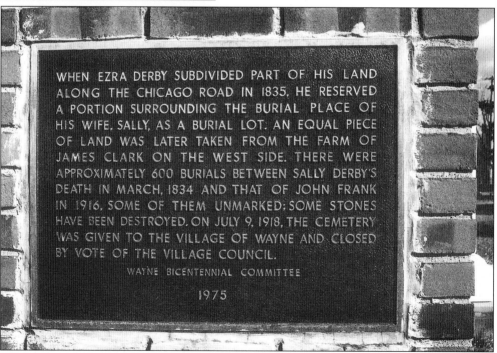

WHEN EZRA DERBY SUBDIVIDED PART OF HIS LAND ALONG THE CHICAGO ROAD IN 1835, HE RESERVED A PORTION SURROUNDING THE BURIAL PLACE OF HIS WIFE, SALLY, AS A BURIAL LOT. AN EQUAL PIECE OF LAND WAS LATER TAKEN FROM THE FARM OF JAMES CLARK ON THE WEST SIDE. THERE WERE APPROXIMATELY 600 BURIALS BETWEEN SALLY DERBY'S DEATH IN MARCH, 1834 AND THAT OF JOHN FRANK IN 1916, SOME OF THEM UNMARKED; SOME STONES HAVE BEEN DESTROYED. ON JULY 9, 1918, THE CEMETERY WAS GIVEN TO THE VILLAGE OF WAYNE AND CLOSED BY VOTE OF THE VILLAGE COUNCIL.

WAYNE BICENTENNIAL COMMITTEE

1975

The Old Wayne Cemetery is a beautiful cemetery located in the downtown area. Its tombstones tell a lot of Wayne's early history. A number of Civil War veterans are buried there.

This farm was on Michigan Avenue where Ford Motor Company is now located. The land was rich and productive like most in the area and supported Michael Stellwagen, his wife, and his seven sons and daughter after they arrived in this country from Germany. Part of the original farm was still in the family in 1950 when it was sold for construction of the factory. It's interesting to note that almost 50 years before, Henry Ford had often stopped at that same site to drink lemonade and chat with Jake Stellwagen.

Philip Stellwagen loved farming and hunting and with his wife, Almira Waltz Stellwagen, continued the family farming tradition although, unlike his father, he had three children, only one of whom was a son to share the farm work.

At one time Wayne was know as the mint capitol of the state. In 1878, it was reported in August in the Wayne County Review that "Brace and Cory have distilled the first peppermint of the season. They have 95 acres of mint and 15 of other crops where three years ago it was all wild." And in September they were reported to have distilled 91 pounds of oil from one-and-five-eighths acres of peppermint.

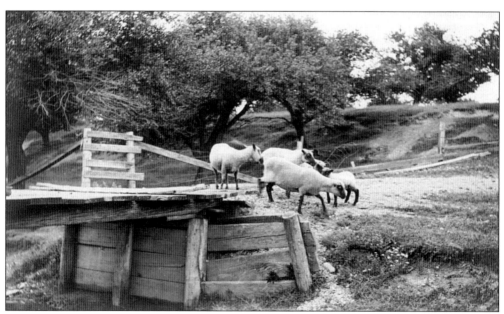

Sheep provided another commodity for which Wayne was well known. Wool was a major product in the area, and these sheep are seen crossing the McClawghrey drain that ran into the River Rouge. There was excellent grazing in the area, and hundreds of pounds of wool were shipped on the Michigan Central Railroad every year.

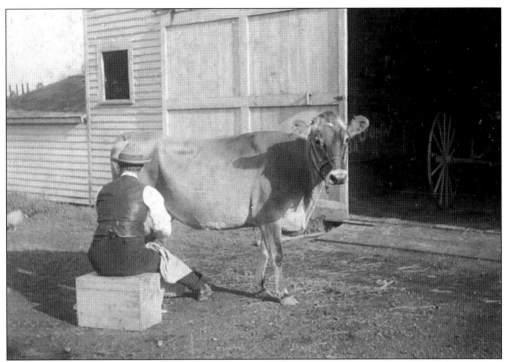

John Bunting is pictured milking a cow in his yard . This was not a farm, just a house with a small building for the cow, horse, buggy, and feed. It was located on Michigan Avenue just east of Howe Road.

Wayne was once the site of a thriving race track located on the flats behind the present day Wayne Memorial High School. A number of farmers raised prize-winning thoroughbreds such as the one pictured above. To provide a judging stand, the bandstand that had been located in the park across from the Village Hall was moved to the flats.

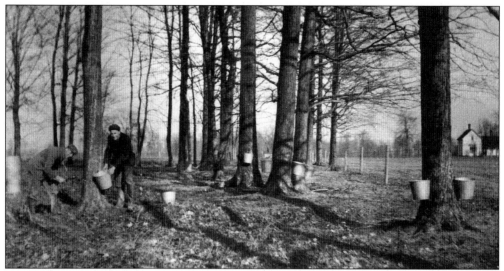

Carpenter's sugar bush seen here was one of many in the area. Art Carpenter has provided information about a number of local sugar bush operations, which utilized different degrees of sophistication in heating the maple sap to produce maple syrup or maple sugar. When settlers first came to Wayne, they found sites where the Indians had already been in the habit of tapping trees and making maple sugar. Some farmer s used open kettles much as the Indians had while others followed increasingly more complicated and precise methods. During one storm in 1911, 42 maple trees were destroyed at Carpenter's sugar bush. Another sugar bush reportedly lost all but a dozen of its 150 trees during a similar storm. That, combined with harvesting the trees for wood, soon brought the days of the local sugar bush to an end.

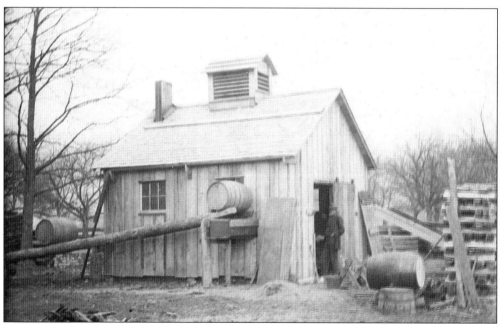

An example of a sap house where the maple sap would be boiled until it reached the correct stage for either syrup or sugar. Syrup was usually made first with later runs, sometimes only the last run, being made into sugar. In the early 1900s maple syrup sold for $2.50 a gallon.

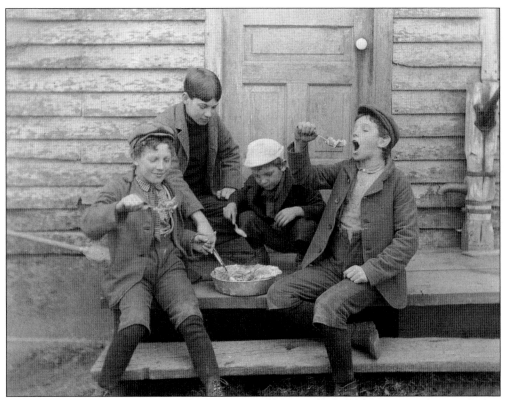

These kids are enjoying a pan of maple sugar. Collecting the pails of sap was often a job that would enlist the help of the children in a family and of friends who hoped to share in the results

This is a picture of the barn and hay stack at the Warner farm on Michigan Avenue between Howe Road and Fourth Street. Much of the farmland had been sold off, and the building in back is Industrial Wire Cloth, providing a contrast of industry and agriculture.

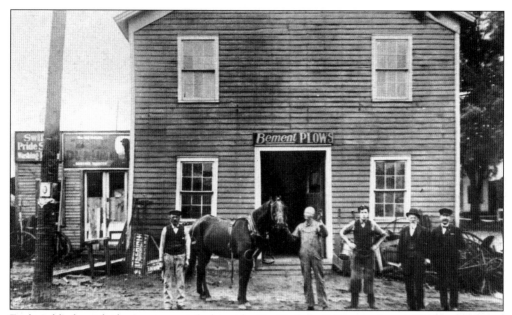

Egeler's blacksmith shop was west of where the Doolittle building was located before it burned. (The Hoops building would be built on that site and was home to O'Brien's Drug Store, then Mulholland's.) Men in the photo are, from left to right, Ernest English, Bert Ackley, Bert Green, John S. Egeler, and an unidentified salesman.

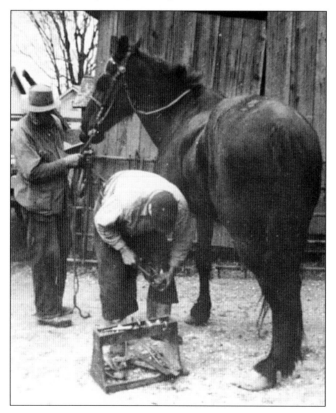

Horses were important, so of course the blacksmith was essential. For this blacksmith, though, his trade outlasted the horse as he became the man who mended anything metal. Bert Green, pictured here, was a fixture in Wayne for many years. He learned his trade as an apprentice at age 13 in Berkshire, England. He came to the United States in 1906 and worked for John Egeler for nearly six years before buying Egeler's blacksmith business. He got 12.5 ¢ for one shoe or 50 ¢ for all four. Though times have changed and he is gone, his grandsons still run the business now located in Westland.

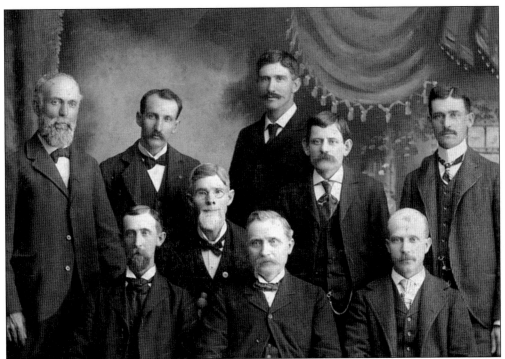

The Village Council in 1900 consisted of, from left to right: (top row) James Hicks, Louis Wendt, J.B. Murphy, Philip Dendel, and Dr. Joseph E. Bennett; (front row) Joseph C. Smith, William Brewer, James R. Hosie, and Clarence Carpenter. These men were poised at the beginning of the new century. The community had gotten through its early growing pains, carved out successful farms, built schools, churches, and a Village Hall, and seen the beginnings of industry. They were looking forward to great growth and prosperity. As business and industry flourished in the Village, a group from Wayne and surrounding townships formed The Greater Wayne Improvement Association. In Article III, it was stated, "The purpose or purposes of this corporation are as follows: To promote mutual cooperation among its members and foster the best interests of Wayne, and the Townships of Nankin, Canton, Romulus, and Van Buren, in the County of Wayne and the State of Michigan; to aid in giving the above district the widest possible publicity through the columns of newspapers; to encourage the building of homes, factories and other industries to engage in a campaign of public improvement as they appear necessary for well regulated, progressive and thriving community."

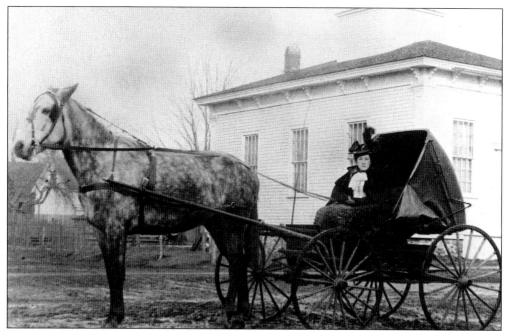

Mae Foss Snyder, wife of John Snyder of Stellwagen and Snyder General Store, is seen here in the transportation of the day. Everyone traveled in this way, and though generally safe, there were accidents with horses being frightened by trains, electric trains, or, eventually, automobiles. Lawsuits were not unknown, either, as when a Romulus man was injured by a team that two weeks previously had killed the owner's father. The lawsuit was for $10,000.

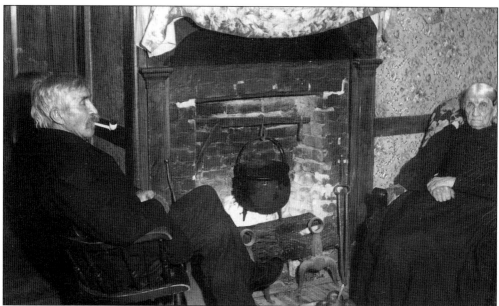

This picture of Otis Warner visiting his stepmother, Olive, portrays a lifestyle that was both harder and simpler than what was to come. It's a cozy picture of relaxing in front of a fireplace where a pot of food cooks, flames warm the room, and a bowl of apples with a paring knife sits invitingly. Olive was born in 1816 and died in 1911. Otis was born in 1836 and died in 1912.

This picture taken about 1904 shows the footpath along Michigan Avenue east of the Village. The electric railroad tracks are visible in the road, which seems little more than a path itself at this point.

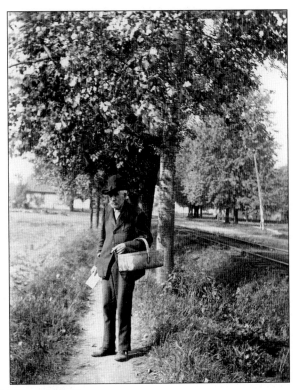

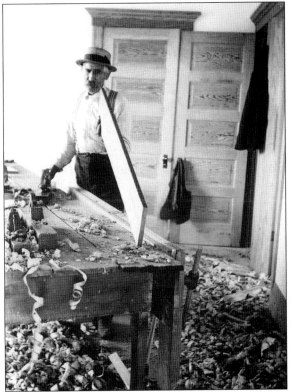

This shows Otis Warner eyeballing a piece of wood. Otis was a carpenter and built homes and buildings in Wayne. According to his daughter, he was generous to a fault, doing excellent work for his customers, and then too often not pursuing payment for his services. This "generosity" meant that the family often needed to live frugally, a habit that became a way of life even when it wasn't necessary.

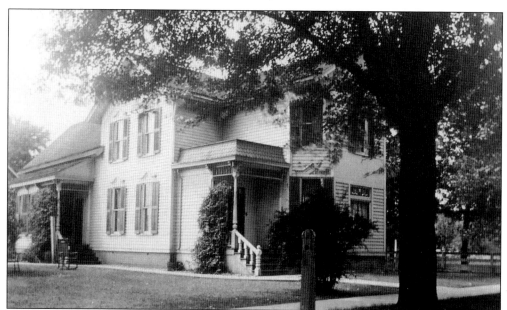

This is the Bradshaw Hodgkinson house that was built by Otis Warner in 1890. "Squire" Hodgkinson, as he was known, apprenticed in Lancashire, England, to a hatter at age 15. Seven years later he came to New York, then to Detroit, and on to Canton. He moved to Wayne in 1875. In 1863, he was elected to the Legislature as a Union Democrat. He worked for the Michigan Central Railroad, farmed, was Justice of the Peace, served on the board of supervisors for Canton Township, clerked in the county treasurers office, was Superintendent of the Poor House in Wayne County, President of the Village of Wayne, belonged to numerous organizations, and died at the home of his daughter, Mrs. Charles H. Cady in 1904. The house still stands.

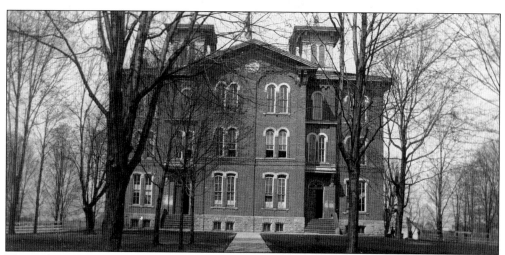

This is the Union School built by Otis Warner in 1870 at a cost of $19,000. It was brick, three stories, and had eight classrooms and a chapel. It was torn down in 1909 because, having allegedly been built on "quicksand," many felt it was unsafe. Roosevelt School replaced the Union School, and the brass bell that was purchased in 1871 for the Union School continued to call children to class at Roosevelt until it was replaced by an electric buzzer. The bell is on display at the Wayne Historical Museum.

Two
EDUCATION

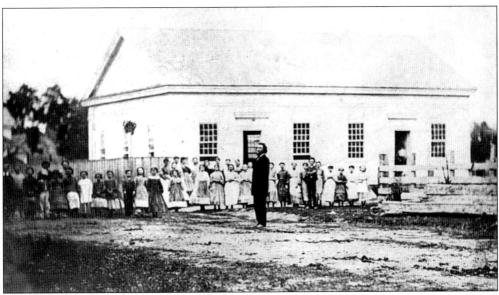

Education was, along with religion, one of the most important issues for early settlers. The first school in Wayne was not a public school. Parents wanting their children to receive formal education arranged for them to be taught by Cornelia Hawley, who by taking on that job started a tradition of education that continues in her family to this day. Her classroom was in a room over a blacksmith shop. Eventually a log building was built, and that in turn gave way to the two-room schoolhouse pictured above. The school was located on the corner of Main and Washington streets, and the teacher shown in the picture is Orson Blair Curtiss. Curtiss had been at University of Michigan before serving in the Civil War where he lost his arm. He returned to finish his education and then taught in Wayne. His book, *History of the 24th Michigan of the Iron Brigade*, is considered one of the best regimental histories of the Civil War. The two-room school was replaced by the Union School and at that point Wayne's school district was on its way.

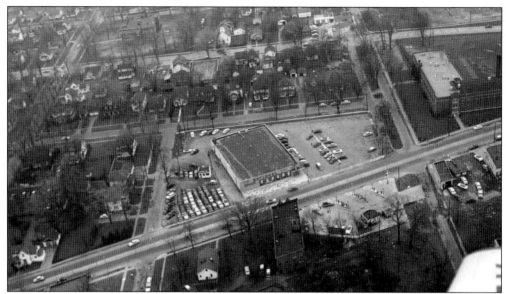

This aerial view of the west end of downtown Wayne shows Michigan Avenue at a diagonal from lower left. Park Street runs horizontally just above the middle of the photo with Clark Street on the left and Williams on the right. The building in the middle of the picture is currently Lower Huron Supply Company, but it was National Food Store at the time of the photo. On the upper right is Wayne High School, and the building at the upper left is Roosevelt School, which sat just about where the new Citgo station is today.

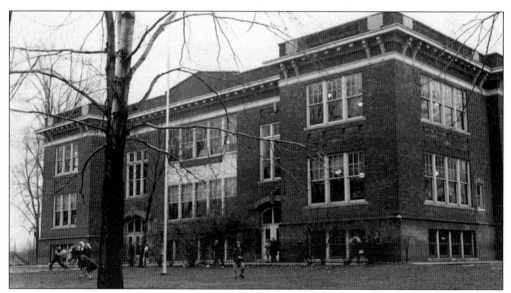

Roosevelt school lives on in the fond memories of many who grew up in Wayne. When it replaced the Union school (at a cost of $32,000), 40 percent of its high school students were non-resident, paid tuition, and came from Flatrock, New Boston, Inkster, Romulus, and outlying rural areas. By 1924, the need for a separate high school was recognized, and Wayne High School opened in 1925 at a cost of $150,000. On Wednesday, March 4, 1964, Roosevelt students went to school, collected their things, said "goodbye" to Old Roosevelt, and were bussed to the new Roosevelt on Currier street. The building was razed for urban renewal.

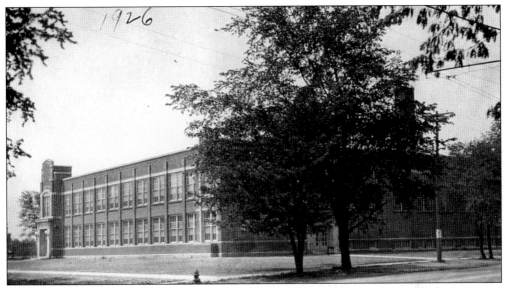

Wayne High School on Williams Street was built in direct response to the greatly increasing number of students in the district. Soon after it opened, Washington elementary school on Glenwood was built. By 1938, there was such a large graduating class that ceremonies were held at the Shafer Wayne Theatre. During the war years the student population grew so fast that high school students were sent to other buildings for classes and finally, Wayne Memorial High School at Fourth and Glenwood was opened. The last class from Wayne High School was graduated from the gym at Wayne Memorial High School in 1952.

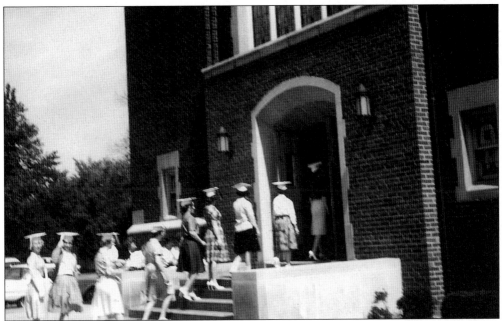

The 1961 graduating class from Wayne St. Mary's School files into church. Ten years later, after 25 years of high school graduates, the last students would receive their diplomas from St. Mary's. Many factors contributed to the decision to continue only the lower grades. At the present time, with new construction and a growing parish, the elementary school is flourishing.

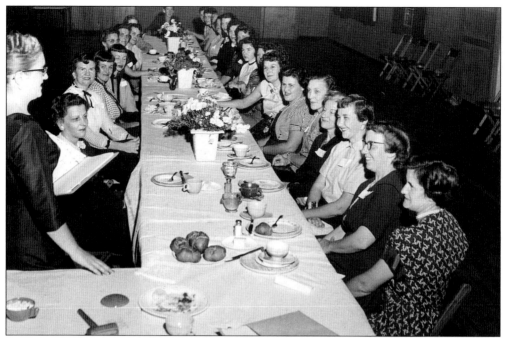

St. Mary's Mom's Club, gathered here, was one of the numerous groups within the church that helped keep programs running smoothly.

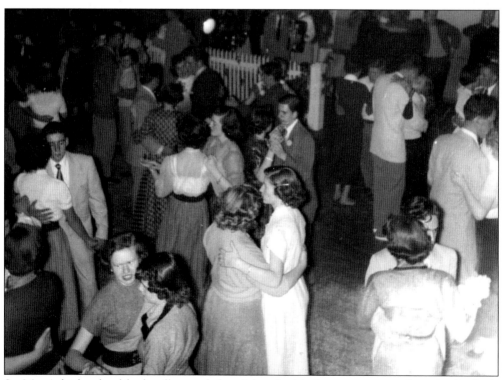

St. Mary's high school had well attended social and athletic events as seen here in this high school dance photo.

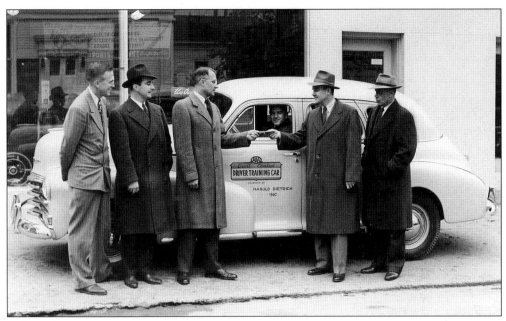

This picture illustrates the community spirit that has always been a big part of business in Wayne. Harold Dietrich donated a car for the driver-education program at the high school. The dual control feature was endorsed by AAA. Seen here, from left to right, are Don Randall (Principal at Wayne High School), Lynn Barne, Stuart Openlander (Superintendent of Schools), an unidentified man in car, Miles Dietrich of Dietrich Buick, and Larry Knox (Wayne Police Chief).

Wayne has had a very progressive attitude toward education, and the district has often led the way in implementing new and better ways of providing services. Miriam Harris, second from the right in the picture above, was an intimidating figure to many for whom she served as school nurse. Her determination and knowledge, however, served the district very well. She was always a leader in seeking cutting edge health and education benefits for local children.

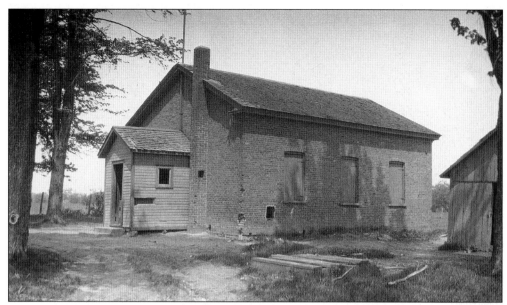

Old Walker school was in the Wayne Public School District even though it was located in Canton. The story of schools in the area is a fascinating one but too long to relate in detail. Rural students attended Walker, Cady, and Patchin schools. Walker and Patchen are still in the Wayne-Westland District. They have been rebuilt and renovated several times. Cady school at the corner of Wayne Road and Cherryhill is a school of the past.

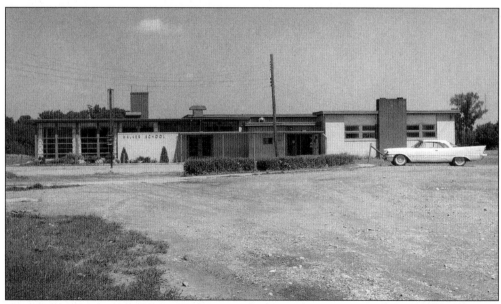

The Walker school of 1970 was vastly different from its country school predecessor. This "modern" building still exists but is not recognizable in its updated form. It has been renamed Walker-Winter Elementary School to honor the late Francis Winter, a much respected District educator.

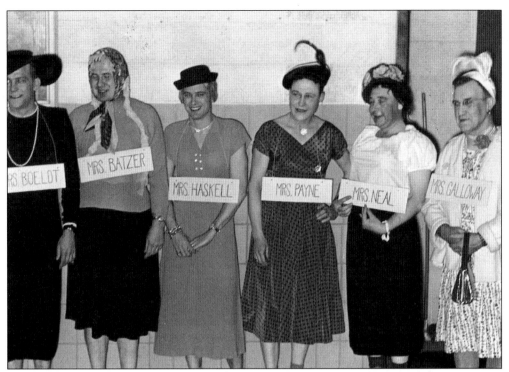

Pictured above are Jackson School PTA members whose enthusiasm and humor is evident in their thespian portrayal of well-known school personalities.

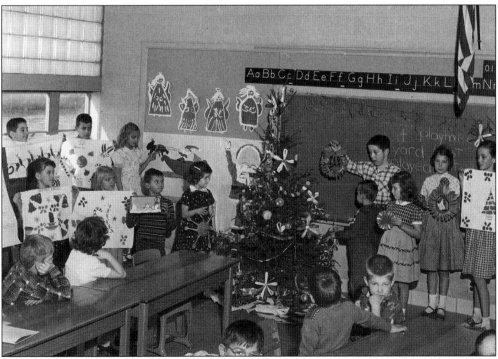

Walker school children gather for a Christmas celebration showing off their artistic creations.

Jackson school was particularly diverse in the programs provided for the PTA, as in this instance, and for the students as well. Located at Venoy and Annapolis roads, the school served a rapidly growing population during the 1950s. In addition, the area had gone quickly from rural to suburban. Teachers capitalized on those changes in planning creative programs. The building became part of the Annapolis hospital complex and was used until recently when it was razed to make way for new construction.

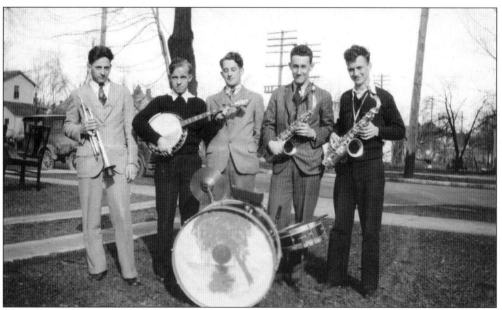

Here the Wayne High School band is represented by, left to right, Alonzo Kleabir, Joe McCool, Arthur Kleabir, Jack O'Brien, and Joe Hargrave. The year is 1929.

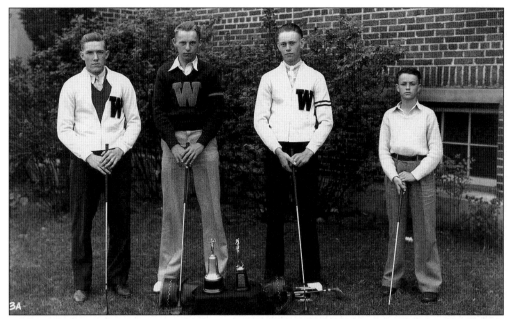

These golfers appear to take their sport very seriously if their expressions are any indicator. They are, left to right, Elmer Prieskorn, John Renauer, Edsel Holmes, and James Carothers. They were the Class B state champions in 1935. Wayne consistently had regional and state champions in a variety of sports from the 1800s.

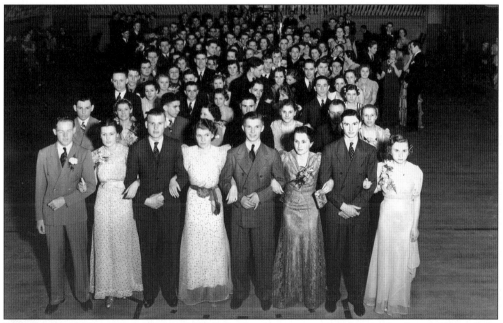

This was the J-Hop for the class of 1938. In the front row are, left to right, James Hisey, Jean Hammond, Arthur Prieskorn, Jean Baskerville, John Flodin, Bernice McConalogue, Earl Finn, and Grace Fraser. A group who calls itself the "'38 Girls" has a tradition to this day of meeting once a month for lunch. The makeup of the group has changed with life changes, but their support and friendship has always been steadfast.

Monthly Reviews and Examinations Tenth Grade. 1898-99.

Samuel Wightman

	Sept.	Oct.	Nov.	Dec.	Jan.	Feb.	Mar.	Apr.	May.	June.	Review Average.	Examination Average.	General Average.	Date.	From	To	Studies Excepted.
READING, Caesar.	92	93	91	91	94	92	92	90	93	91			92	6/22 '99	10	11	
WRITING, Alg.	93	93	98	96	88	95	95	97	95	91			94				
SPELLING, Rhet.	94	90	90	93	89	–	–	–	–	–			91				
MATHEMATICS, Phys. Geog.	95	97	94	94	96	–	–	–	–	–			95				
LANGUAGE, Music.	90	90	98	–	–	–	–	–	–	–			93				
FORM, GEOGRAPHY, Rhet.?	90	–	90	–	–	–	–	90	–				90				
HISTORY, BOTANY, English.	–	–	–	–	–	89	87	94	89	90			90				
PHILOSOPHY, ASTRONOMY, Am. Hist.	–	–	–	–	–	96	95	94	92	92			94				
ZOOLOGY, CHEMISTRY,																	
PHYSIOLOGY, GEOLOGY,																	
DEPORTMENT,	91	93	92	93	90	91	93	94	92	94			92				
TARDINESSES,	0	0	0	0	4	0	0	0	0	0			–				
HALF-DAY ABSENCES,	0	0	0	0	0	0	0	0	0	0			–				
DISCIPLINED,	0	0	0	0	0	0	0	0	0	0			–				

Myra Barnard.

	Sept.	Oct.	Nov.	Dec.	Jan.	Feb.	Mar.	Apr.	May.	June.	Review Average.	Examination Average.	General Average.	Date.	From	To	Studies Excepted.
READING, Caesar.	90	93	93	91	90	91	93			90			92	6/22 '99	10	11	
WRITING, Alg.	96	99	99	98	97	99	95		100	96			97				
SPELLING, Rhet.	94	91	92	94	93	–	–		–	–			93				
MATHEMATICS, Phys. Geog.	96	88	96	95	96	–	–		–	–			94				
LANGUAGE, Music.	95	98	98	–	–	–	–		–	–			97				
FORM, GEOGRAPHY, Rhet.?	93	–	–	90	–	–	–		–	–			92				
HISTORY, BOTANY, English.	–	–	–	–	–	90	90			92			91				
PHILOSOPHY, ASTRONOMY, Am. Hist.	–	–	–	–	–	95	91			91	Examined and gone away and gone north.		92				
ZOOLOGY, CHEMISTRY,																	
PHYSIOLOGY, GEOLOGY,																	
DEPORTMENT,	94	95	96	96	96	95	96						95				
TARDINESSES,	0	0	0	0	0	0	0	0					–				
HALF-DAY ABSENCES,	1	3	0	0	0	3	13	14					–				
DISCIPLINED,	0	0	0	0	0	0	0	0					–				

Edith Hooper.

	Sept.	Oct.	Nov.	Dec.	Jan.	Feb.	Mar.	Apr.	May.	June.	Review Average.	Examination Average.	General Average.	Date.	From	To	Studies Excepted.
READING, Caesar	89	90	90	92	91	90	90	91	88	93			90	6/22 '99	10	11	
WRITING, Alg.	91	94	96	93	87	88	92	88	89	90			91				
SPELLING, Rhet.	87	90	89	91	89	–	–	–	–	–			89				
MATHEMATICS, Phys. Geog.	92	89	94	93	93	–	–	–	–	–			93				
LANGUAGE, Music.	95	98	96	–	–	–	–	–	–	–			96				
FORM, GEOGRAPHY, Rhet.?	93	98	–	–	–	–	90	–	–	–			93				
HISTORY, BOTANY, English.	–	–	–	–	–	90	91	93	90	91			91				
PHILOSOPHY, ASTRONOMY, Am. Hist.	–	–	–	–	–	95	91	93	91	91			92				
ZOOLOGY, CHEMISTRY,																	
PHYSIOLOGY, GEOLOGY,																	
DEPORTMENT,	92	94	93	94	93	94	92	93	95	94			93				
TARDINESSES,	0	0	0	0	0	0	0	0	0	0			–				
HALF-DAY ABSENCES,	0	0	0	1	0	0	0	1	0	0			–				
DISCIPLINED,	0	0	0	0	0	0	0	0	0	0			–				

Agnes Kurtz.

	Sept.	Oct.	Nov.	Dec.	Jan.	Feb.	Mar.	Apr.	May.	June.	Review Average.	Examination Average.	General Average.	Date.	From	To	Studies Excepted.
READING, Alg.	92	94	97	94	80	84	89	85	88	90			89	6/22 '99	10	11	
WRITING, Rhet.	86	89	78	90	89	–	–	–	–	–			86				
SPELLING, Phys. Geog.	87	88	89	92	92	–	–	–	–	–			90				
MATHEMATICS, Int. Arith.	93	88	91	85	90	–	–	–	–	–			89				
LANGUAGE, Music.	90	96	98	–	–	–	–	–	–	–			95				
FORM, GEOGRAPHY, Rhet.?	85	90	–	–	–	–	96	–	–	–			92				
HISTORY, BOTANY, English.	–	–	–	–	–	92	92	94	93	92			93				
PHILOSOPHY, ASTRONOMY, Am. Hist.	–	–	–	–	–	95	93	94	92	92			93				

The list of classes high school students were required to take around 1900 was a little different than today's offerings. Most students who stayed in school did well. If they were not doing well, they usually left to work on the farm or in a factory as industry became more common. Some students weren't able to attend high school even if their grades were good because they were too important to their families farming efforts.

Three

RELIGION

The history of religion in Wayne goes back to its first settlers. People met in each other's homes or barns until the congregation could build or share more formal space for worship. Over the years there have been so many churches, it is impossible to do justice to them all. Only the older buildings have been selected, and no intent is meant to slight any person or religion. The people of Wayne have been dedicated to a wide variety of religions and through them have often contributed to the community through programs of giving and reciprocity.

St. John's Evangelical Church pictured here was located on Elizabeth Street. It was a beautiful old stone church of Ohio blue granite that was torn down during urban renewal. It was dedicated in 1921 and met the wrecking ball in 1967. The membership was largely of German descent, and in earlier days, sermons had been given in German and English. A Lutheran school was also located on Elizabeth Street for a time. It later moved to Wayne Road in Westland, and when the church was earmarked for demolition, a new building was built on Glenwood around the corner from the school.

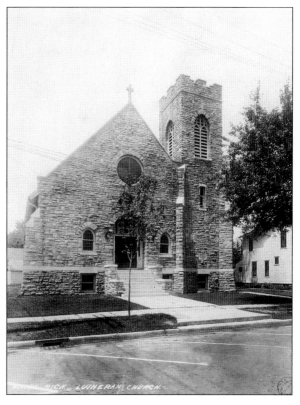

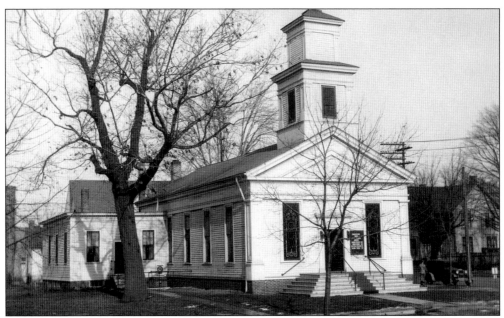

The First Congregational Church of Wayne was founded in 1848. The church was built in 1849 and was originally 32.5 by 44.5 feet. The windows were clear with shutters. The isle inside was not wide enough to accommodate moving a coffin, so the furthest window to the north on the east side was made longer than the rest to be the coffin exit for funerals. One of the many changes in the building occurred in 1876 when the church was split and lengthened by adding to the middle. Renovation was in progress in August of 1970, when the church burned to the ground. The church was rebuilt in a different style.

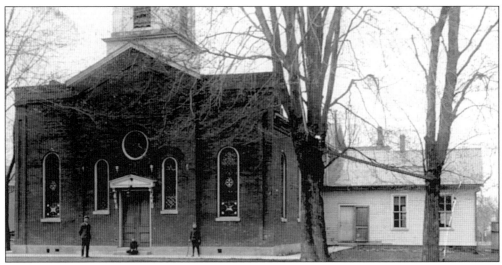

This Methodist-Episcopal church was built to accommodate the congregation that had previously held its services at the Congregational church. It was dedicated in 1863 and had cost $3700. The last service in the church was 67 years later when the pulpit Bible, pulpit, and Communion table were carefully carried over to the new church on Newberry. The stained glass windows were also saved, and the church was sold at auction and torn down. The first pipe organ in the history of Wayne was installed here in 1890.

The Universalist Church was built about 1863 at the northeast corner of Norris and Newberry. In 1904, a 58-year lease was given to the Episcopal Church. The building first faced Norris, then was moved to the north end of the lot facing Newberry.

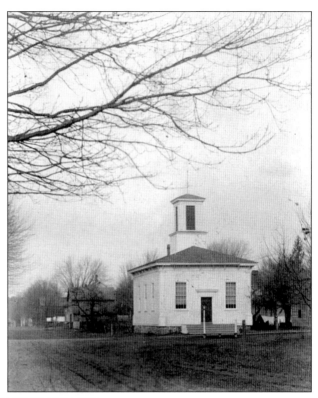

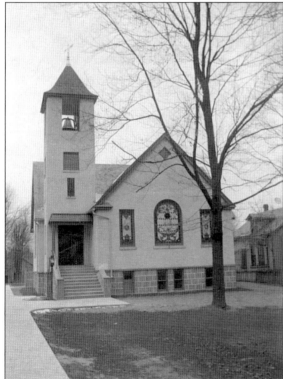

The First Baptist Church of Wayne was built at the corner of Main and Monroe in 1904 at a cost of $4500. By 1940, the congregation had grown and a series of additions were built. As the congregation grew and urban renewal approached, the church bought ten acres of land on Glenwood and, in 1962, dedicated their new church. The new site included a complete gymnasium, a softball field, and housing for some of the church staff.

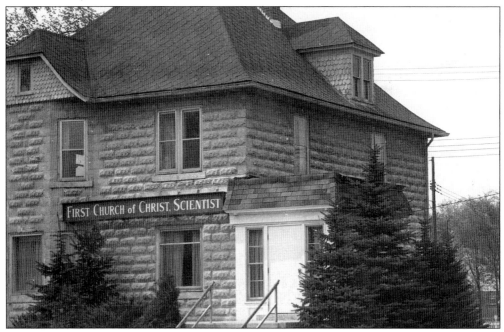

The First Church of Christ Scientist is located on Michigan Avenue in what used to be the Bevernitz house.

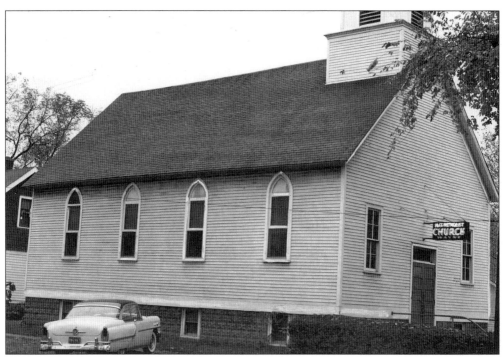

The Free Methodist Church was located on the southwest corner of Main Street and Clark. It occupied a building built by a group from St. John's Lutheran Church who had separated from the parent church about 1906 or 1907 under the Missouri Synod. The building was later purchased by the "Re-organized Church of Christ of Later Day Saints."

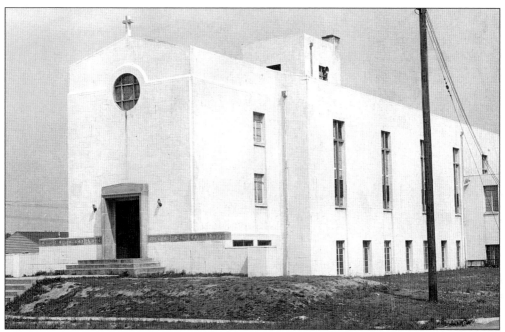

This is the Norwayne Community Church located at the southeast corner of Grand Traverse and Venoy.

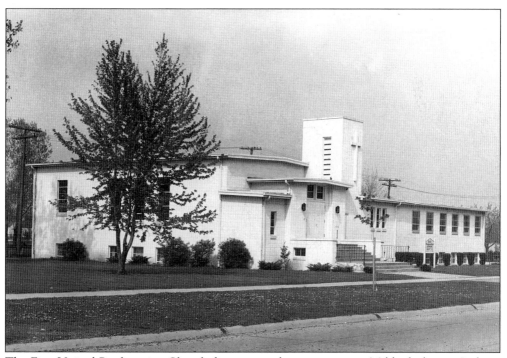

The First United Presbyterian Church first met at the parsonage on Mildred, then at Jackson Elementary School. In 1949, land was purchased on the northeast corner of Venoy and Annapolis, and the chapel unit was built. In 1954, the education wing was added, and subsequently, the entire structure has been remodeled.

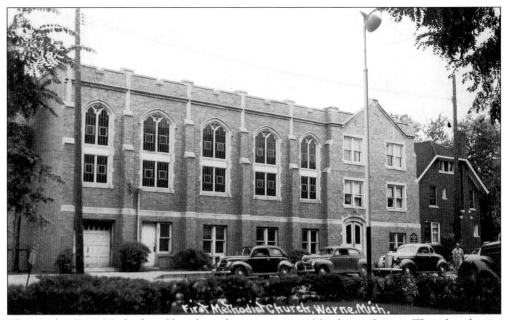

This is the First Methodist Church and parsonage on Newberry Street. The church was dedicated in 1929. It served until completion of the present sanctuary in 1967.

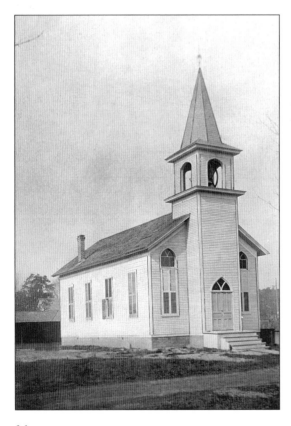

The first Evangelical Lutheran Church building in Wayne was dedicated on August 20, 1877. It was a little frame building that subsequently was torn down and the wood used as part of the building materials for the Lutheran school.

Four
RIVER, ROAD, AND RAIL

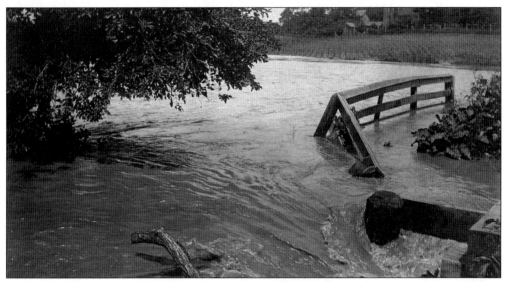

The River Rouge, as it was originally called, meandered across lower Nankin Township long before settlers arrived in the area. It was the line followed by the Old Indian Trail and artifacts of the Pottawotami tribe were found in the vicinity through the 1950s. Wayne is on a flood plane, and for years settlers thought that the land was too swampy for farming. When George Johnson opened his tavern in 1824, and Orange Risdon surveyed the Chicago Road (the east-west highway through Wayne has been known as the Plank Road, The Chicago Road, the Toll Road, U.S. 12, U.S. 112, and Michigan Avenue) in 1828, people discovered that the land was very good for farming if allowance was made for spring flooding. The Chicago Road made access more convenient and settlers began to arrive. Floods from spring thaw and later storms meant that people from north of the river who might be in town for one reason or another had to get home quickly if a flood seemed imminent. Sometimes school children would be stuck in town if flooding occurred while they were in school. The river also meant recreation, and it was used for summer canoe and rowboat excursions. Fish were plentiful and local swimming holes were frequently occupied. However, the river was not totally benign. Over the years a number of people have died when underestimating the power of the river during flood stage, and at least one person in the early 1900s died of a broken neck when diving from the Farmington Road abutment. Then, following closely the surveying of the road, came the railroad and with it the beginnings of great change.

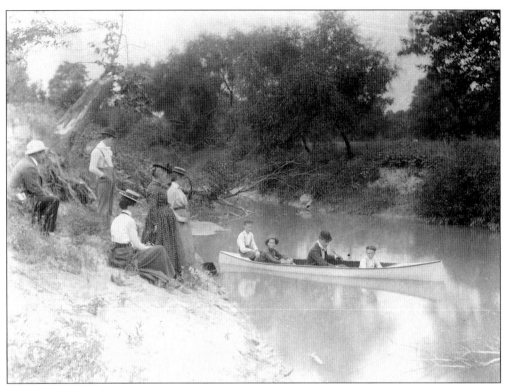

The river was a popular place for summer picnics. Fishing was great. There were many "favorite" swimming holes, and canoes and rowboats were always out on summer Sundays.

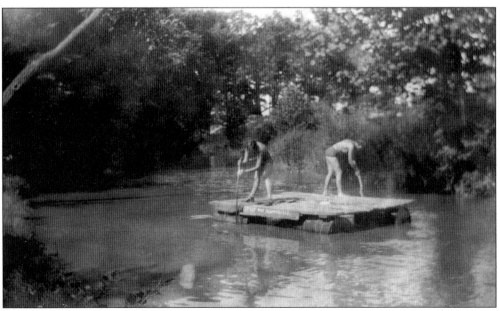

Sisters Dorothy Wilkinson Ballantine and Ruth Wilkinson Hawley enjoyed their raft on the Rouge River at the foot of Clark Street, *c.* 1930s.

CARPENTER'S LAKE

TOURIST CAMP

IS THE

Only Lake Camp Near Detroit

Located 2 miles West of Wayne; 30 rods North of Michigan Avenue and 10 miles East of Ypsilanti, Michigan on U. S. 112

BATHING — CANOEING — SPRINGWATER — LIGHTS — STORE
COTTAGES AND TENTS FOR RENT — KITCHEN FOR TOURIST AND PICNIC
GROUNDS — OTHER ACCOMMODATIONS — CLEAN GROUNDS
BUS SERVICE TO DETROIT AND OTHER POINTS. *Please Post this and send yours on.*

Phone 7131F2
Wayne, Mich. IRVING CARPENTER, Prop. **Camping 50c**

Carpenter Lake was a great place for recreation, was the site of a yearly Gypsy encampment, and served as the bathing spot for men at the local Civilian Conservation Corps camp.

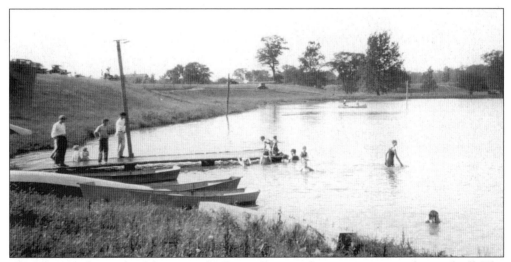

The lake was the result of damming the Rouge River and pumping water in by windmill. The lake ceased to be when polio epidemics were claiming so many victims. The cause was unknown, but water was suspect. Greyberry apartments now stand where the lake once was.

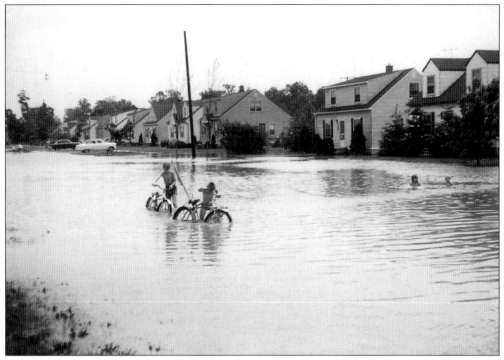

Living on a flood plain was serious business for drivers but great fun if you were a kid.

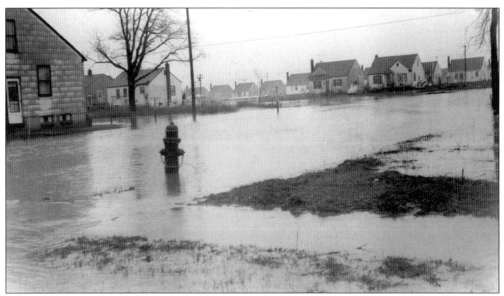

The Boice Drain was the site of this flood on Winifred. After particularly serious flooding in 1968 and 1969, measures were taken to resolve the problem. The community now rarely has more flooding problems than the normal spring thaw along the Rouge River.

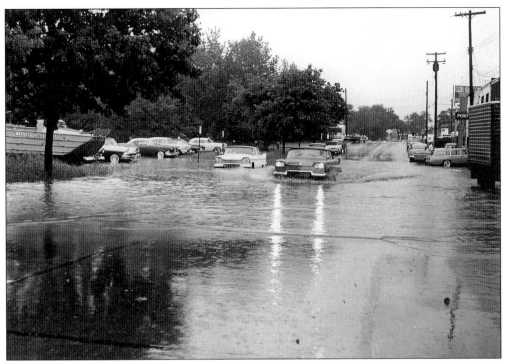

This scene is on Sims Street looking east toward Michigan Avenue. At the time, Red Holman Pontiac was on the point. The Wayne County Sheriff was involved because of the severity of the flooding.

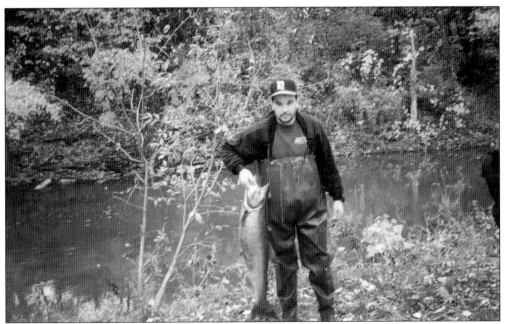

After years of pollution, the river is returning to a more environmentally friendly state as evidenced by this fish taken from the river between Wayne Road and Second Street by the Michigan Department of Natural Resources in 1996.

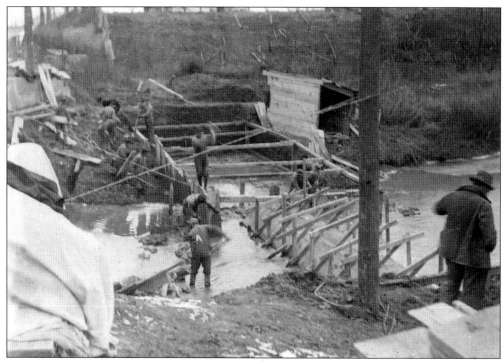

This picture was taken in 1913 when the waterworks dam was being built across Wayne Road.

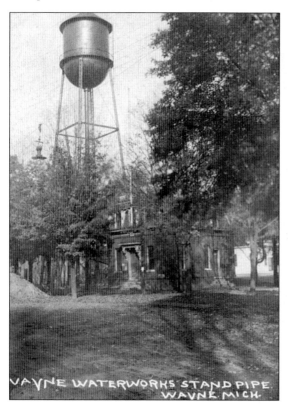

VAYNE WATERWORKS STAND PIPE
WAYNE MICH.

The Wayne waterworks standpipe is pictured here behind the Village Hall. The Village Hall was built in 1878 for $1300. Henry Sherman had the distinction of being the first person confined in its new cells and that was before the dedication had taken place. Prior to the new building, the lockup had been constructed of wood and was two rooms where those who had over imbibed were locked in and left to sleep it off.

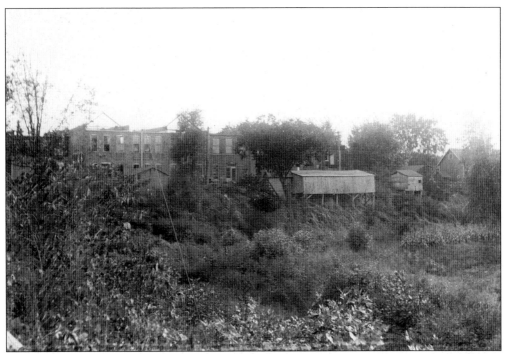

This scene, *c.* 1900, is of the rear of buildings facing Michigan Avenue. Before the river was diverted to its present channel, walking carelessly out one of the back doors of those buildings could have sent the unwary plummeting into the river.

The Old Second Street bridge is one that tickles the memories of many who literally flew across it. Narrow and at the bottom of a hill, it was a "thrill" spot for drivers for many years. In January of 1976, the old bridge was taken out, and by September of that year the new 40-foot wide bridge and new pavement from Ash to Sims meant a gentler, smoother ride across the Rouge River.

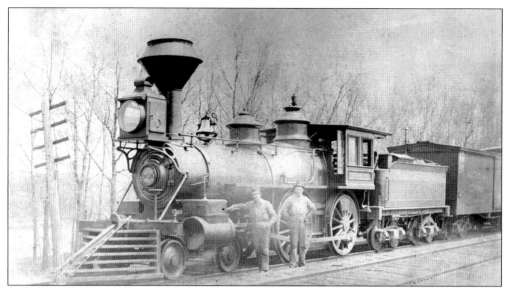

This engine with the bulging smoke stack is Engine #245 and was stopped on the Michigan Central Railroad track in Wayne.

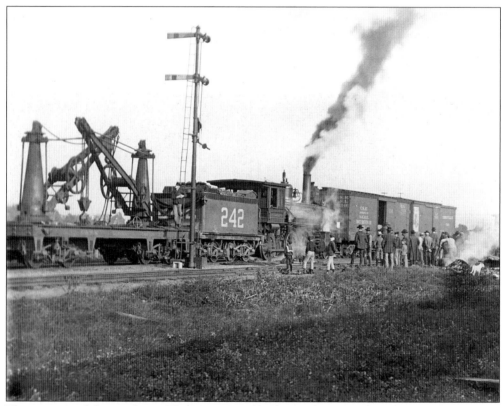

This image is of the wreck car. The train is on the Flint and Pere Marquette railroad just north of the junction with the MCRR. The MCRR was through Wayne in 1838; the Flint and Pere Marquette was open to Wayne in 1871.

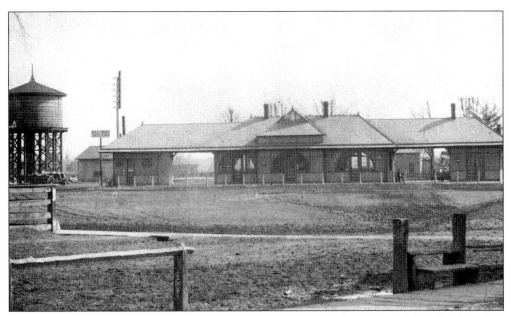

This is the Wayne station on the Michigan Central Railroad. The town had first developed on the Chicago Road, then moved to the railroad as it assumed greater importance in transportation. With the coming of the automobile, however, the center of town shifted once again to the highway at the intersection now known as Michigan Avenue and Wayne Road. The importance of the railroad was noted in the *Wayne Review* in December of 1878 when it was reported that "one day last week one of the most valuable trains that ever passed over the MCRR passed this station. Six cars loaded with $18,000,000 worth of silk-worm eggs, going to France."

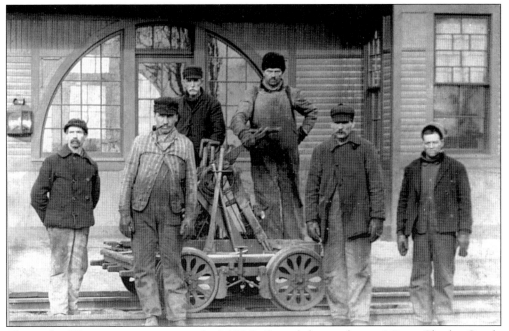

This is the Wayne section crew on the MCRR. From left to right are ? Ross, Charles Goudy (section leader), Charles McCollister, unidentified, William Clark, and Park Durham.

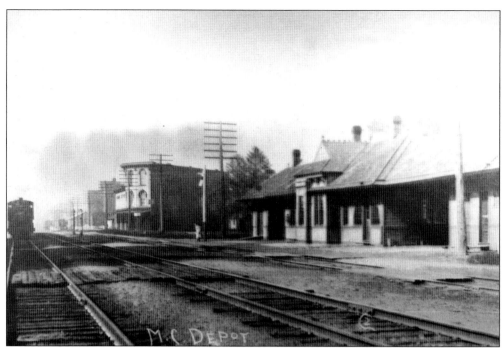

This is a long view of the station and Steers building in the distance on the other side of Monroe. The year is 1910.

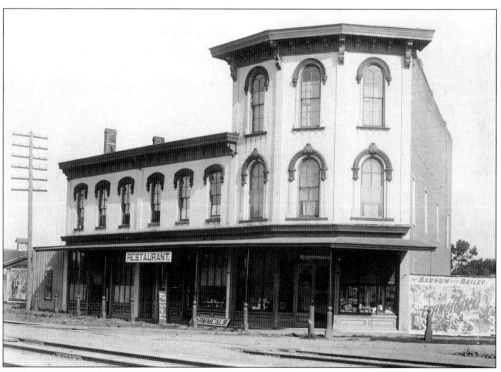

A closer look at the Steers building shows the restaurant advertising warm meals and a bill board for Barnum and Bailey.

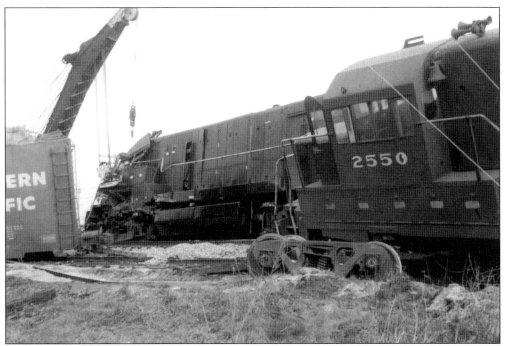

Railroads were very important but were also the cause of a lot of damage. At one point the dangerous speed of 11 miles an hour was thought to be unsafe. It seems strange to think of horse and buggy accidents with trains, and yet a number of early residents met their end in such a way. Trains also scared horses into throwing their riders. And even in modern times, derailments such as this aren't unusual.

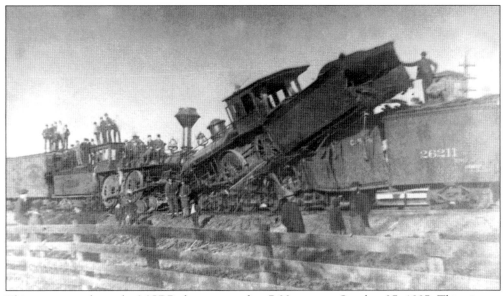

This was a wreck on the MCRR that occurred at 7:00 a.m. on October 27, 1887. This picture was taken for Hiram Crosby who was the conductor on the train at the time of the accident.

Railroads are controlled in offices in far away places these days, but in 1940, people worked in railroad towers like this one at the junction in Wayne. Their job was to control rail traffic and keep it safe and efficient.

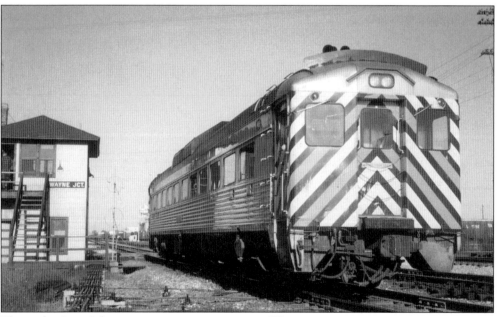

This is the Ann Arbor commuter train stopping in Wayne.

This 1912 steam locomotive is passing the house that would become the office for Hawley's coal yard.

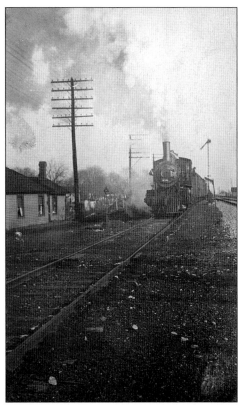

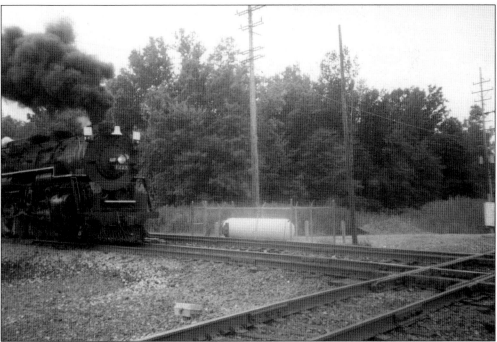

The majesty of the steam locomotive was captured as Engine #1225 raced toward the crossing at Wayne junction as it headed back to Lansing in August of 1991.

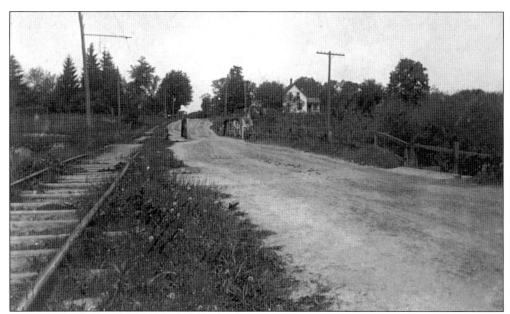

This view north on Washington is from 1906. The road hadn't been paved yet, but the electric railroad track made traveling to Plymouth and Northville a much easier trip.

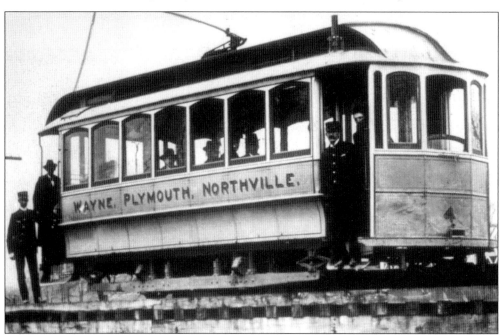

This electric car is like the one about which the newspaper wrote in 1903: "Last winter passengers on the D.P. & N. Electric Line nearly froze to death every time they took a trip on the dinky cars but it is different now and the new arrangement is both novel and healthy. Live wires are run thru the cars, being placed under the seats. The seats are covered with a piece of carpet, and the faster the cars run the hotter the seats get, and sometimes it gets too hot for the comfort of the passengers. If a passenger succeeds in riding from Wayne to Northville in a continuous setting he will get a prize donated by those who have tried it and failed."

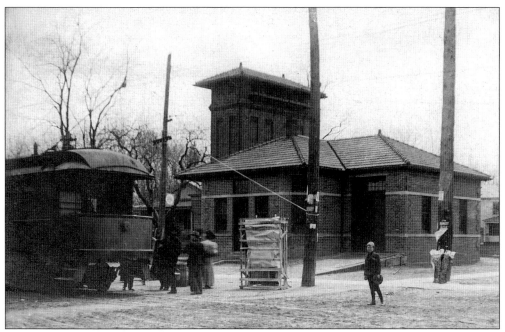

The Electric Depot was on the corner of Michigan Avenue and Washington. Emil Gerbstadt said the business in his bakery, which was across the street, picked up tremendously after the depot was built.

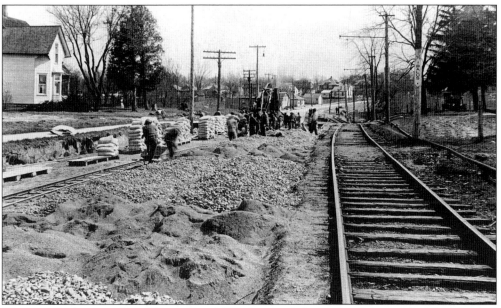

This view looking south on Wayne Road (Washington) shows the electric railroad tracks, and the paving of the road is underway. There were, unfortunately, many accidents with the electric trains. On Michigan Avenue, L.F. Wendt lost three head of cattle, one outright and two who were so badly mangled that they had to be destroyed, because the conductor was "asleep or not paying attention." The newspaper editor urged "turning the case over to the extent of the law." In other instances, individuals fell under the car and were injured or killed.

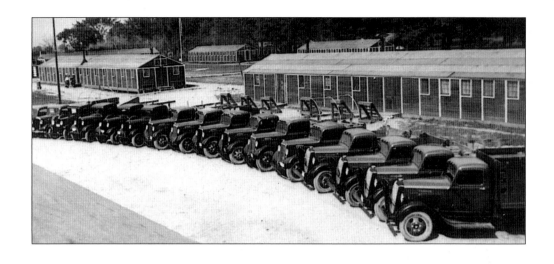

The top photograph shows the barracks and trucks of CCC (Civilian Conservation Corps) workers. The photograph below shows the result of some of the work not yet completed in April of 1937. Mulching and placing of guy wires remained to be done. Two hundred young men were housed on Hix Road at Camp Wayne. They were assigned to do roadwork and plant trees on Michigan Avenue from Dearborn to Ypsilanti.

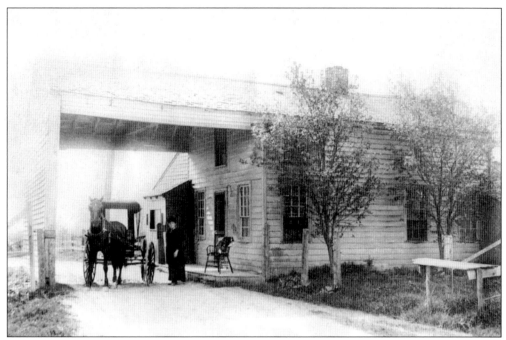

The Chicago Road was a toll road, and this picture shows the tollgate at Cogswell Road. Another tollgate was located between Sims Street and St. Mary's Cemetery. Farmers often tried to go around the gates to avoid paying the per-head fee for livestock. The chair seen in this image is on display at the Wayne Historical Museum.

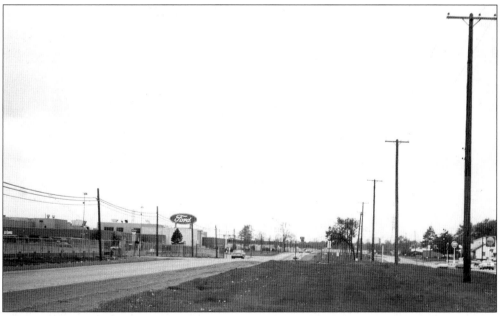

This scene is looking west on Michigan Avenue toward Newburg Road. The Ford plant was built in 1952. Just west of this straight piece of highway used to be "dead man's curve" where many accidents occurred, which caused that stretch of highway between Wayne and Ypsilanti to be called the most dangerous in Michigan.

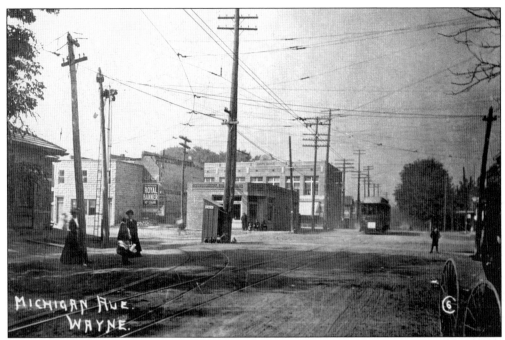

This 1910 picture of Michigan Avenue in Wayne shows the wide dirt road with the electric car approaching the station. The large building in the center of the picture is the Hoops building built in 1908 and that may be remembered by some as the home of Mulholland's Dry Goods. Egeler's blacksmith shop is just west of the Hoops building.

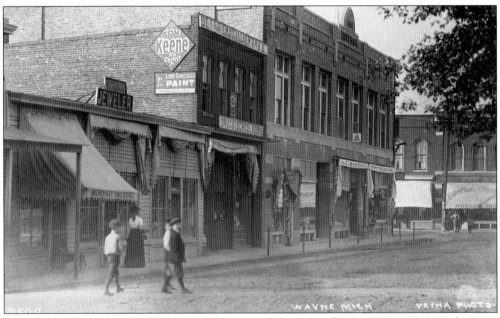

This was Monroe Street in 1911. A tailor shop, jewelry store, Detroit White Leadworks Paint Store, A.C. Randall's, and O'Brien's Central Drug Store are on the west side of the street. Hanging from the corner of the building is a sign for Dr. E.R. Lee, Dentist. Across Michigan Avenue is Morton Bros. Furniture and Undertakers.

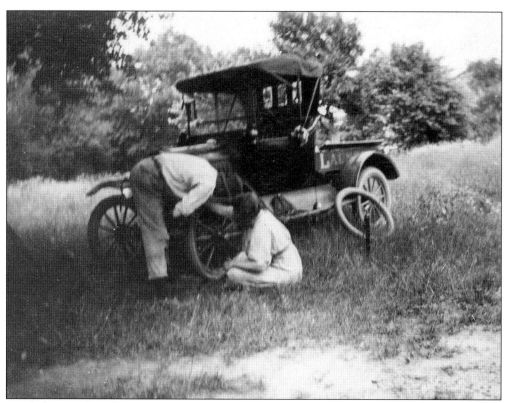

Roads being what they were, it wasn't unusual to have a flat tire. Here the Wayne Steam Laundry delivery truck gets a tire changed by Maud Beyer and an unidentified man.

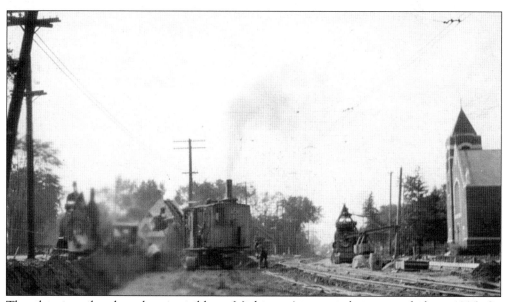

The electric railroad tracks are visible as Michigan Avenue is being paved about 1925. St. Mary's Catholic Church is on the right. Most of the rails were removed for scrap during the war.

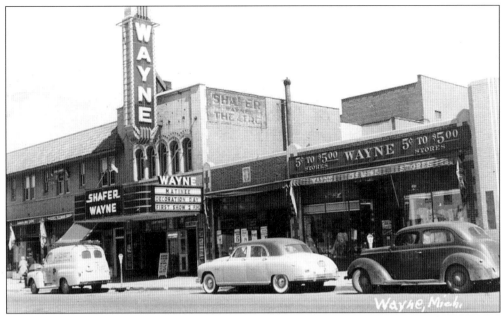

This view of Michigan Avenue stores shows, from left to right, Varsity Hat Shop, Stein's Florist, the Shafer Wayne Theatre, C.F. Smith grocery store, and Collin's dime store.

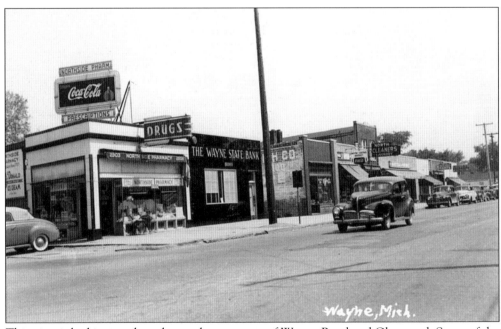

This view is looking south at the southeast corner of Wayne Road and Glenwood. Some of the businesses located in that block were Northside Pharmacy, The Wayne State Bank, the Wayne Central Market, North Cleaners and Laundry, and Gates Market.

Five

EXTRAORDINARY PEOPLE

In the history of Wayne there have been many remarkable people—civic leaders, politicians, clergymen, educators, businessmen, and industrialists. There have also been those who were nurtured here, then left to find great success elsewhere in law, sports, entertainment, education, and dozens of other fields. Picturing those people alone could fill volumes. It was difficult making choices of who to include and who to leave out because so many from all walks of life have had interesting stories and have added to Wayne's development. Pictured here is Roger Cullen, father of long time Wayne City Manager, Pat Cullen. While Roger delivered the Detroit Journal, some of his less well-occupied peers were into mischief of the day such as tarring or greasing the door handles of various businesses in town.

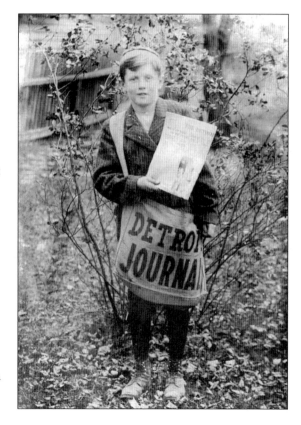

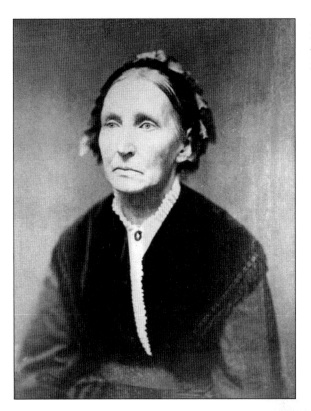

Pamela Pattison Chubb was born on June 11, 1808, in New York and moved with her family to Superior Township in Washtenaw County.

Glode Dugar Chubb was born on April 26, 1796, in Poultney, Vermont. He purchased land in Bucklin Township in 1826. In 1828, he married Pamela Pattison. They had seven children. One daughter died in childhood, and a son, Lucius Wolford Chubb, died in a hospital in Philadelphia from wounds received at Gettysburg. Lucius was buried at the family cemetery located on the north side of Warren Road, a quarter mile west of Hix Road. In 1853, the Chubbs moved to a farm one mile east of the Village of Wayne at Michigan Avenue and Venoy Road where the Walgreen Drug Store is now located. In 1866, the Chubbs moved to a home he built on Brush Street. Glode Chubb was described as an ardent Whig and Abolitionist during the existence of those two political parties. Then he became a staunch Republican. He voted in every presidential election. His house at the Rouge River was one of the stations on the Underground Railroad. Pamela died in 1884. Glode died in 1888 at the age of 92. Both were buried at the "Chubb burying ground," also known as the Hayward Cemetery.

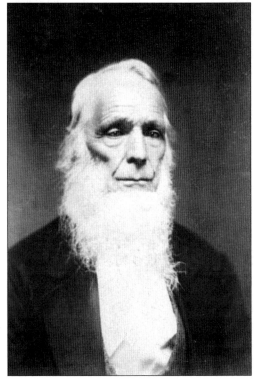

Charles H. Cady was born July 20, 1842. On May 4, 1864, he married Mary Jeannette Hodgkinson, daughter of Bradshaw and Alice Hodgkinson. He was a farmer and teacher (teaching at both Patchin and Cady schools). He ran a meat market on the corner of Monroe and Park Streets. He built a slaughterhouse that was "very interesting to us children, as we often watched the process of butchering and preparing the hides for sale to the tanners and preparing the meat to be sold in the market." He served as Supervisor of Nankin Township and as President of the Village of Wayne, and was in the state legislature, traveled to all of the counties, and was instrumental in having the Michigan College of Mines located at Houghton. He also devised a way to have the northern counties help with taxes. He had lived in the Swift house on Michigan Avenue (later the Anning house) but lived on Clinton Street until he died on April 14, 1923.

Mary Cady, daughter of Bradshaw and Alice Hodgkinson, married Charles Cady in 1864. She had taught school and was a charter member of the Ladies Aid Society at the Methodist Church. She also belonged to the Wayne Ladies Library Association in the early 1880s. She died on September 23, 1931.

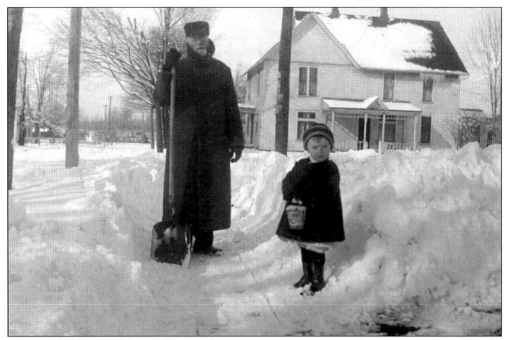

Blacksmith John S. Egeler and his grandson, John Egeler Vallance, had their work cut out for them on this snowy day in 1912. Notice young John was wearing a skirt, the fashion for young boys at that time. John Vallance later would own Northside Dry Goods and Hardware, the store now known all over western Wayne County as Northside True Value Hardware.

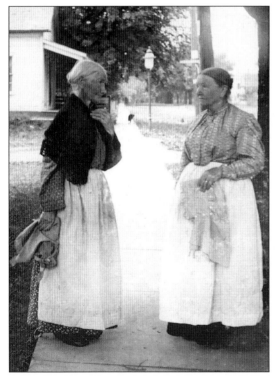

Pictured here are two Irish friends, Margaret Cullen on the left and Bridget Fitzgerald on the right. They are standing in front of the Cullen house on Michigan Avenue east of Fourth Street. One of the news streetlights is visible in the background.

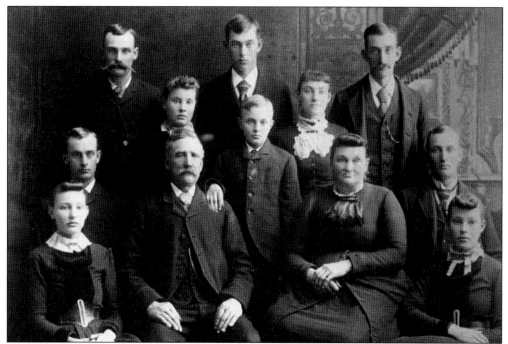

The Charles Carpenter family has many connections to Wayne. In the back, left to right, are Charles E., George, and William. In the middle row are Carrie and Emma, and in the front are Fannie, Henry, Charles, Grant, Clarissa, Irving, and Minnie. Irving Carpenter was the owner of Carpenter Lake.

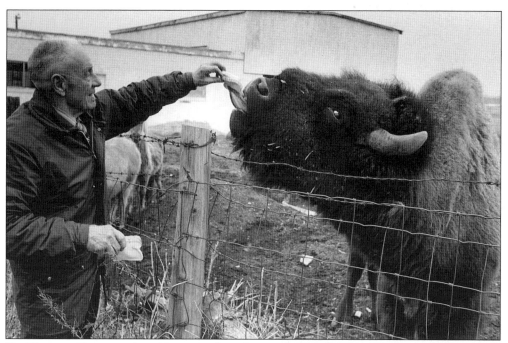

Dr. Clarence Carpenter loved his animals and rescued many from certain disaster, often taking in animals that were injured or abandoned.

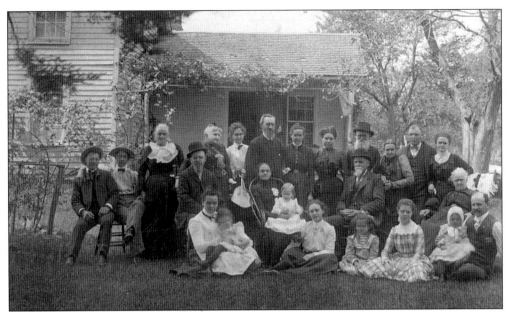

The Thomas Ackley family is seen here at a reunion *c.* 1900. Thomas Ackley was born in Phelps, New York, in 1828, and moved here in 1851. During 1852–1858, he worked on the first United States survey of Lakes Michigan, Superior, and Huron. Mrs. Ackley was Laura M Palmer, daughter of John Milton and Margaret Palmer. The Palmers were among the earliest settlers to the area.

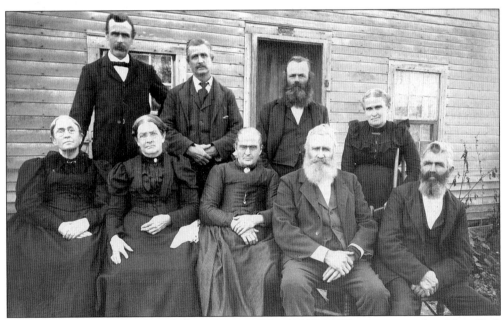

Benjamin Hix (1795-1857) and Electa Ferester Hix (1805-1867) were married in New York where five of their nine children were born. In 1836, they moved to Michigan and settled on a farm on The Old Plank Road (Michigan Avenue) and Cogswell. From left to right are: (back row) Hiram Hix, William Hix, John Hix, and Ellis Hix Rhead; (front row) Ruth Hix Robinson, Jane Hix Trowbridge, Cloey Hix Dawson, Amos Hix, and Lorenzo Hix.

Officers of the Epworth League of the Methodist Church were, clockwise from upper right, Susie Doolittle, Alice Cady, Myra Barnard, Nellie Freeman, Lillie Oakes, and Anna Cady, president, in the center. This is 1902 or 1903, and the Epworth League met once a week with a social gathering once a month. Other early community organizations included the Ancient Order of United Workmen, Modern Woodmen of America, Free and Accepted Masons, Grand Army of the Republic, the Grange, Knights of Honor, United Order of Druids, Ladies' Library Association, Woman's Christian Temperance Union, Woman's Relief Corps, and Order of the Red Cross. In 1960, there were over 70 community service and social organizations in Wayne.

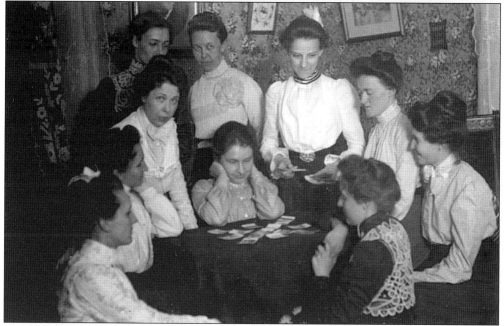

This is a picture of a Spinster's Club meeting. These young women got together to talk about social issues and enjoy a good time, perhaps telling their fortunes as seen here or playing cards. Only three of the group, Ida Collar, Emma John, and Floy Warner remained true to their "spinster" name. Pictured are Floy Warner, center, having her fortune told, and her friends, clockwise from lower left, Alice Cady, Emma John, Lulu Blackmore, Mamie Chaffee, Ida Collar, Anna Cady (who is telling the fortune), an unidentified visitor, Nellie Freeman, and Anna Chamberlain.

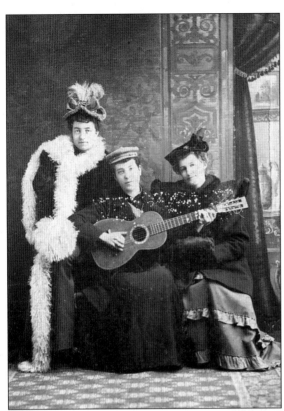

Florence Stellwagen, Bertha Marker, and Margaret Hawley seen here left to right, enjoyed music and a very active social life.

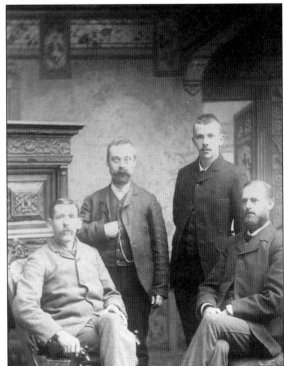

These four gentlemen were know as the Wayne Quartet and were, left to right, Fred Marker (bass), Henry Barnard (tenor), John Marker (baritone), and Dr. Zimmerman (lead).

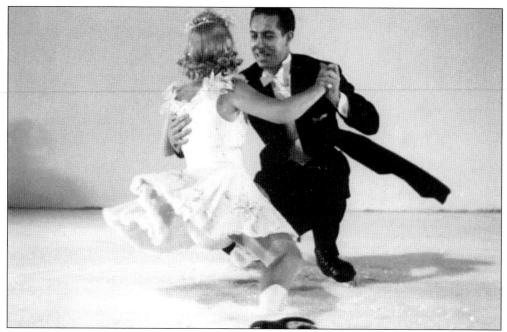

Ted Harper and his wife were both figure skaters. Ted skated professionally as partner to 1930s and '40s star Sonja Henie.

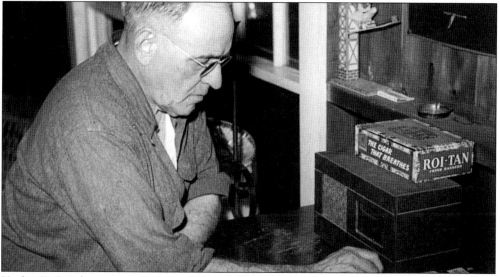

Harley E. Smith was very active in Wayne. His wife was Harriet Smalley Smith, daughter of Mary Palmer Ackley Smalley. Harley was described as a rugged individualist who was always ready to help anyone who had any "gumption." He was a civic leader involved with business, real estate, and the school board. He was general manager for Detroit Soda Products, on the boards of Wyandotte Terminal Railroad, and the Peoples Community Hospital Authority. He was on the advisory board to the National Bank of Detroit. He matched, with money from his own pocket, $10,000 raised for a building addition by the Women's Sunday School Class of the Methodist Church. He loved hunting and fishing so much he formed a hunt club that used his lodge at Onaway as its campsite.

Dr. James Caraway (1899–1974) was not a native of Wayne, but he came here to practice medicine in 1927 and made the place a major part of his life. In addition to starting a local hospital with Dr. Huff, he was instrumental in the collecting of early Wayne history. His notes and records were meticulously researched, and he enjoyed his role in the community as president of the Kiwanis Club, member of the American Legion, and as a founding member of the Wayne Bank. He is seen here looking at some of the earliest acquisitions for the museum.

Floy Warner was born in 1876 to Otis and Ellen Warner. After graduation in 1895, she taught at Patchin School for three years. Without money for college, she got three degrees by correspondence: a Bachelor of Arts degree from the University of Indiana in 1899; a degree in applied science from the International Correspondence School in 1905; and in 1927, she started her last degree in English from the University of Chicago. She studied sewing and electrical wiring by mail, also. When her siblings married and moved away, she was left to care for her father after her mother's death. She worked for a while at the local newspaper, tried her hand at running a greenhouse, and finally established the Wayne Steam Laundry. She loved Wayne and its history. In her will she left a substantial amount to help fund a museum.

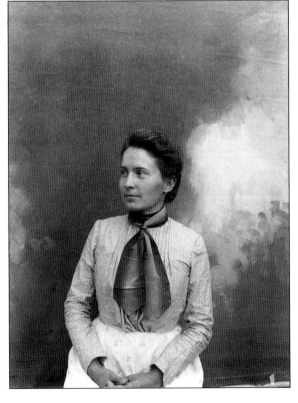

Six
DOWNTOWN

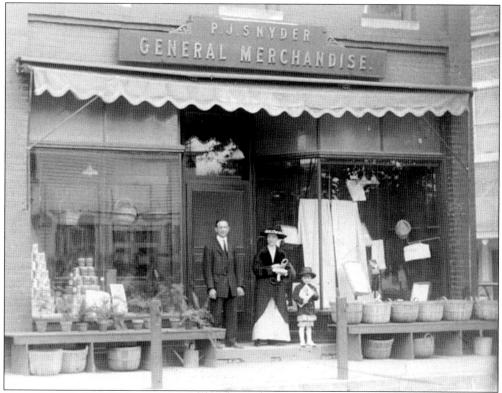

P.J. Snyder General Merchandise was one of many stores in Wayne. This is around 1915, and there was a pretty big variety of shops and businesses. Among them were four hotels (there had at one time been six), three hardware stores, three meat markets, a cigar store (cigars were made in Wayne), six lumber yards, three shoe stores, two banks, two lawyers, two automobile service stations, two dentists, three doctors, an Edison office and a telephone company, and the Alseum (a moving picture theatre where movies were shown twice a week). There were some strange combinations like the man who advertised paint *and* optometry. There were sales of agricultural implements and a bike and motorcycle shop. One could buy jewelry or take music lessons, buy ice or go to the Opera House. It was a great place!

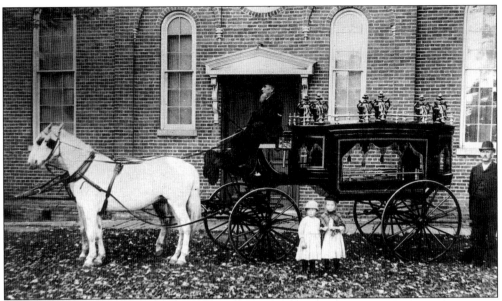

This was the first hearse in Wayne. It was owned by A.F. Ditsch and is seen here in about 1890.

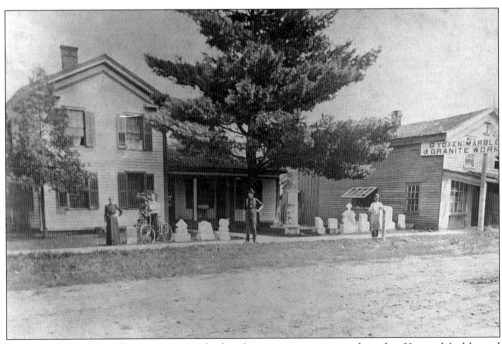

Many of the early tombstones seen in the local cemeteries were purchased at Yoxen Marble and Granite Works. This was at the corner of Park and Washington (Wayne Road).

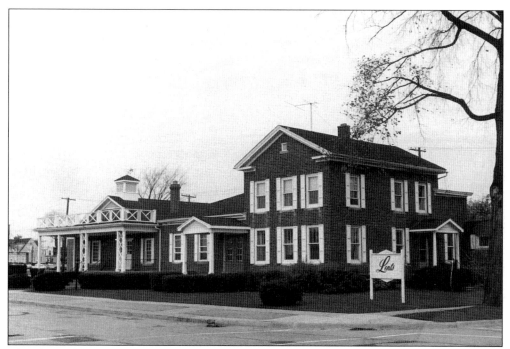

This funeral home was Lent's, and it was located on the northwest corner of Main and Second streets.

Uht's Funeral Home was on Main Street. Mantous Uht had purchased the building and added an apartment and brick veneer.

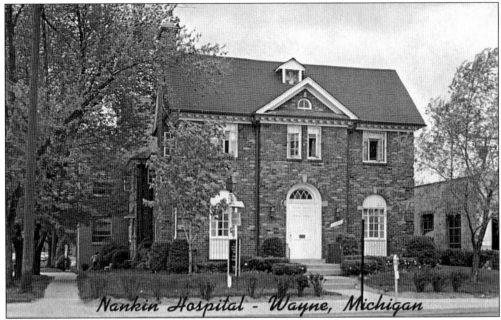

Nankin Hospital - Wayne, Michigan

Nankin Hospital was built as the Wayne Clinic for Dr. Reginald G. Huff and Dr. James Caraway and opened in 1932. The building continued as a hospital until a circuit court judge ordered its 1973 owner, Dr. Rene Archambault, to discontinue keeping overnight patients. Dr. Archambault believed bureaucrats were attempting to stamp out small hospitals. He closed his practice in 1976.

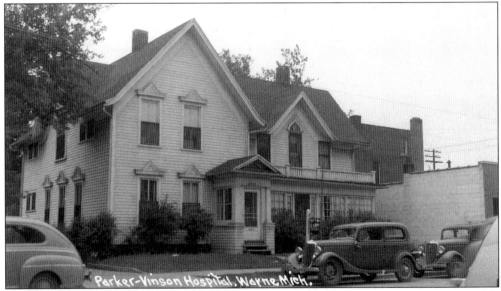

Parker-Vinson Hospital, Wayne Mich.

The Wayne community has had a number of hospitals over the years. Its hospitals were built and run by doctors who practiced and lived in the area. Parker-Vincent Hospital was a relatively small, homey place dedicated to the emotional as well as physical comfort of its patients. Dr. Parker was much loved in the community and was devoted to preserving the history of the Greater Wayne Area.

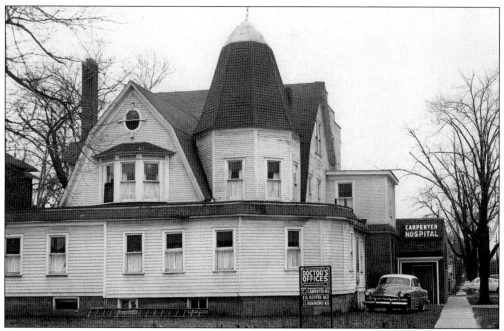

Carpenter Hospital was run by Dr. Clarence Carpenter, a colorful and often outspoken man whose love for people was only rivaled by his love for the animals he rescued. His clinic/hospital was located in various places at different times. Problems getting his clinic relocated during urban renewal almost sank the whole renewal project in Wayne. The State of Michigan had an established time line that wasn't being met. The south 17 feet of Carpenter Hospital was needed but wasn't available because no new location was yet ready for occupancy. Last minute relocation saved the day. Later disputes resulted in Dr. Carpenter moving to the south side of Van Born Road—in the Township of Romulus—but still the greater Wayne area!

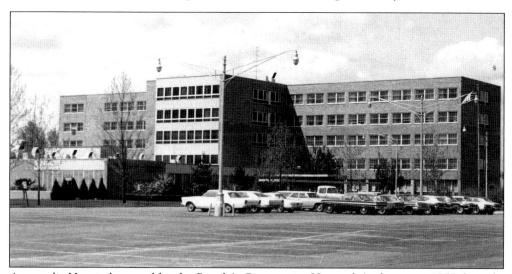

Annapolis Hospital, started by the People's Community Hospital Authority in 1957, brought the newest and best of community hospital technology to the area. Over the years both controversy and growth have been part of its evolution into a member of the Oakwood Health Care System.

Much has been written about Eloise and Wayne County General Hospital. Adjacent to Wayne, it served as health care facility and place of employment for a large number or Wayne residents. This flowerbed is reminiscent of the nationally renowned flowerbeds Eloise boasted.

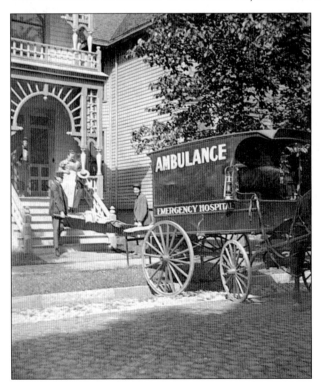

This is 1901 with the emergency ambulance. Dr. Earle, a well-known Wayne doctor, is standing on the porch at the left.

The Morrison house was the first example of this particular architectural construction in Michigan. Preservationists felt very strongly about the building and attempted to save it at one point by forming a human chain around it. It was torn down in 2001.

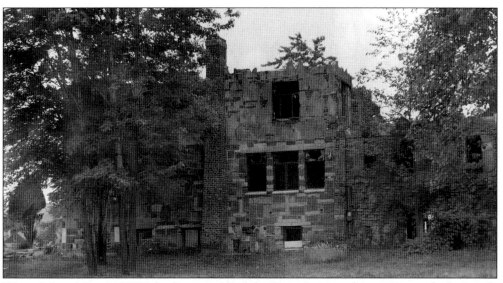

Wayne's "castle" at 31555 Tyler Street was built by Curtis Leggo to keep a promise he had made to his wife to give her a castle. It was completed in 1943 and got international attention. Constructed mostly of stone and scrap materials taken from other buildings being torn down, it included wood from the old Vernors building on the Fairgrounds, slate from a church on Woodward Avenue in Detroit, headstones, curbstones, packing boxes, stones from the world's deepest mine, and pieces from the *USS Constitution*. The fireplace contained 50 stones representing 50 countries around the world (there were certified letters to support this claim). Engineers have said, "It's lucky he wasn't an engineer, or he would have known he couldn't do all the things he did!" The house was torn down during urban renewal.

This brick house dates to 1865. It was owned by a lawyer named Baluss and was built on the north side of the Rouge River overlooking what used to be a farm on the river flats. It was recently torn down to make way for Wayne's new fire station, which is expected to open in 2004.

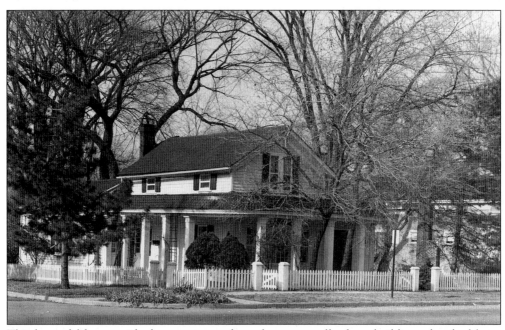

This beautiful house with the wrap around porch was actually three buildings that had been joined together. The owner of the house loved it so much that when is was about to give way to urban renewal, she hired a local builder to duplicate it exactly on property she bought in Canton. The only differences were the updated wiring and plumbing and the brick that covered it instead of wood siding.

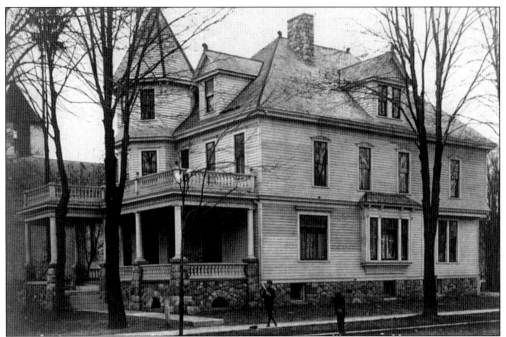

This house belonged to the George H. Stellwagens and was on Monroe facing the Village Park. It was built in an era when people living both in the country and in town enjoyed social events. There was the Opera House, Berdans ballroom in Canton, the Palace Skating Rink (used for skating, dances, parties, and all other social events), the Union Hotel ballroom, to mention just a few. In that framework it doesn't seem so strange to know there was a ballroom on the third floor of this house.

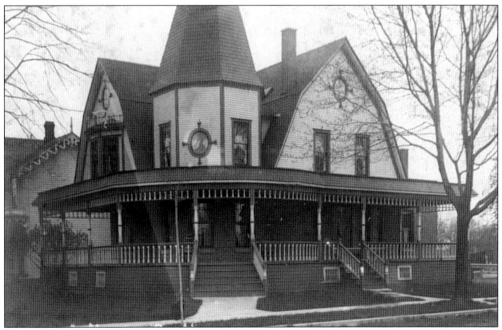

This house was owned by the Moore family. It became in later years Carpenter Hospital.

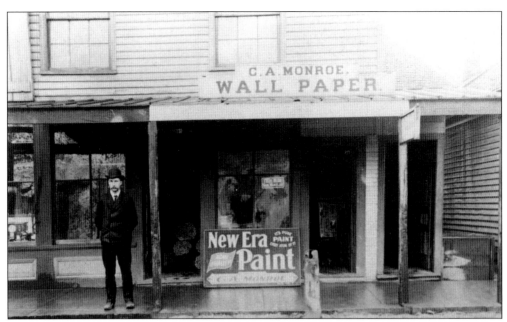

Many stories can be told about Charlie Monroe. He had just about anything one could want in the line of wallpaper. He had paint—and much, much more. And he also advertised his skill as an optometrist. This image is of his store on the east side of Monroe. He later moved to the west side of Monroe at the corner of Brush.

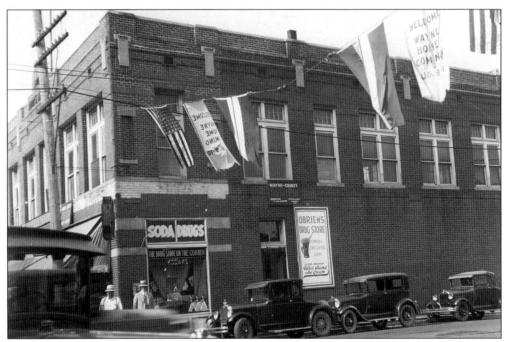

This is the southwest corner of Michigan Avenue and Monroe. O'Brien's Drug Store sign advertises sodas made with Velvet Brand Ice Cream. Above and slightly to the left is a sign directing people to the Monroe entrance of the Wayne-County Review. The banner across Michigan Avenue is a welcome to the Wayne Home Coming, August 9–10.

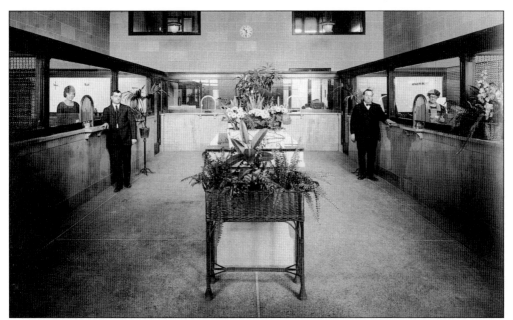

This is the inside of the Wayne Savings Bank in the mid-1920s. On the left are Elsie Proctor and John Truesdell. On the right are Kate Varney and George M. Stellwagen.

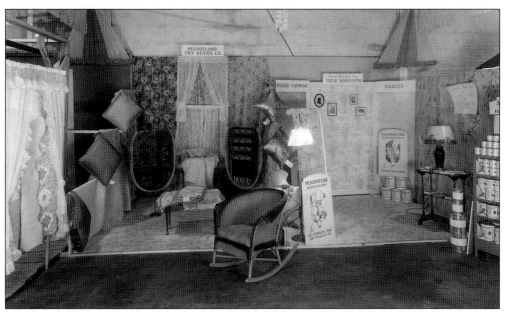

This picture was taken at the Wayne Better Homes and Garden Show in 1931. A showcase for the community, it provided merchandising opportunity and a freeze frame of the styles and goods of the day. The struggle through the depression had just begun, but the community retained its optimism. Unfortunately, before it was over, people would be picking up coal along the railroad and pulling down moldings and trim in some of the towns finest houses in order to have heat. Some families would end up renting garages or moving in with several other families where there were not adequate accommodations. The town survived, and by the 1940s, it was once again on top of the industrial game.

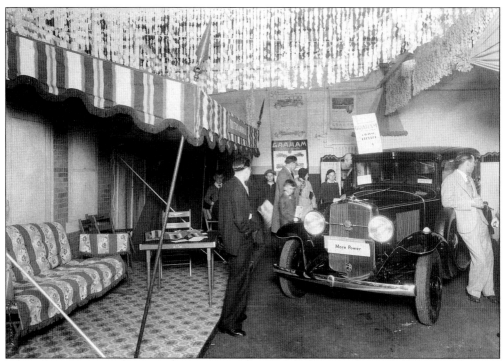

At the 1931 Home and Garden show, the Graham Paige car built here in Wayne, was a star.

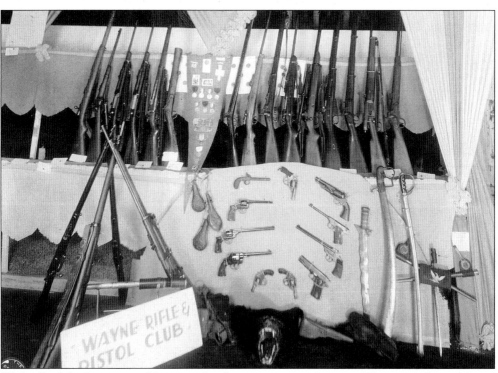

With all of the hunting and history of military service in the area, Wayne's Rifle and Pistol Club was very popular, and its members owned some remarkable weapons.

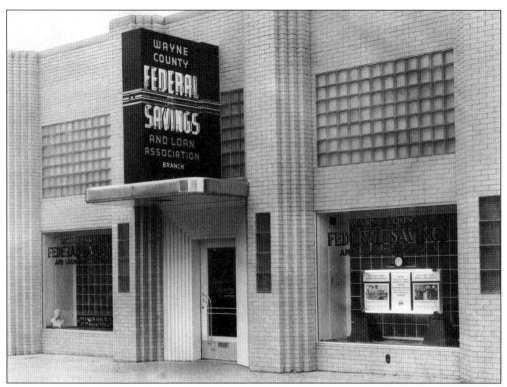

The Wayne County Federal Savings and Loan Association at 35150 Michigan Avenue is pictured here when the building was new in 1940. It was one of many institutions of its type that found success in industrial Wayne.

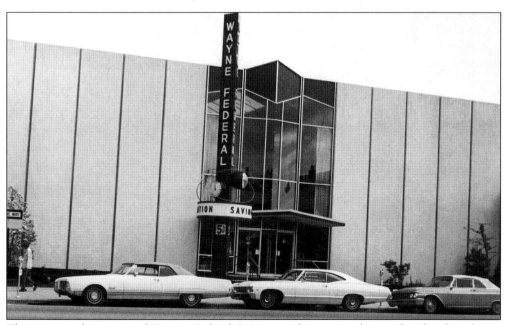

This is an early picture of Wayne Federal Savings and Loan on the north side of Michigan Avenue opposite Biddle Street.

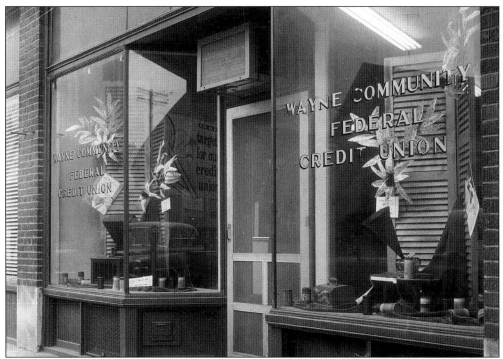

The Wayne Community Federal Credit Union was located in the Lee Gerbstedt Building on Monroe, *c.* 1959.

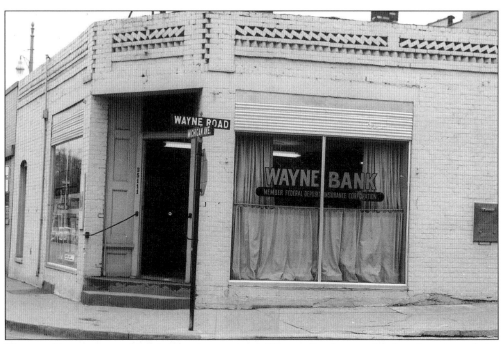

The southeast corner of Michigan Avenue and Wayne Roads was the first location of the Wayne Bank. The building had previously been Carlton's Meat Market during WWII and then an office supply store.

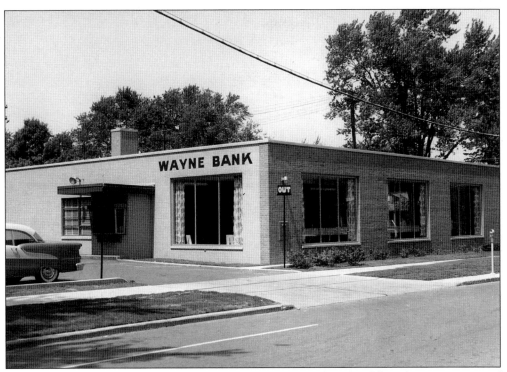

This was the new Wayne Bank building at the corner of Park and Biddle. The new concept of drive-thru banking was a reality at this location.

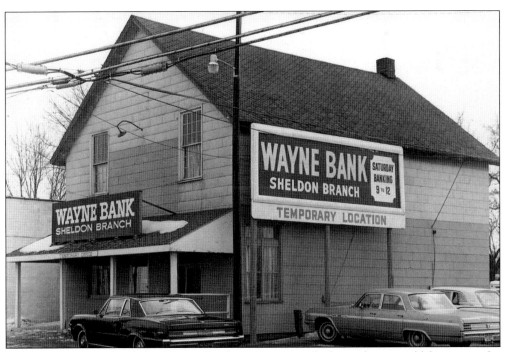

The Sheldon branch of the Wayne Bank was temporarily located in an old house on the southeast corner of Michigan Avenue and Sheldon Road.

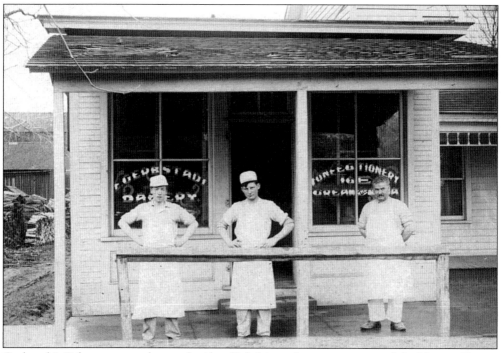

Gerbstadt's Bakery was on the north side of Michigan Avenue just east of the Varney House. Pictured here are, left to right, George H. Gerbstadt, Clyde Allen, and Emil H. Gerbstadt.

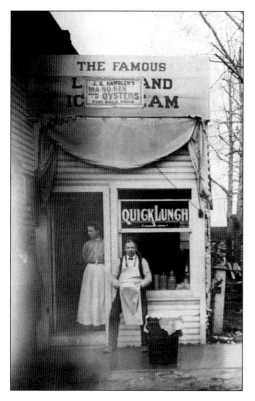

It wasn't quite fast food, but they did advertise a "quick lunch" at Cadwell's Restaurant on the north side of Michigan Avenue between the Varney House and Gerbstadt's Bakery. Pictured are Rose Robinson and Ed Cadwell.

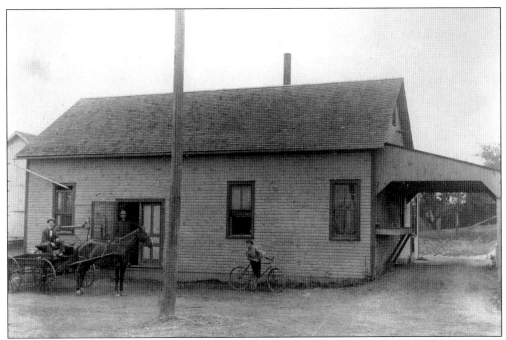

The Wayne Creamery was an important part of early business. At one time, butter and eggs were shipped into Ohio. Receipts show that they were packed in ice to keep them fresh.

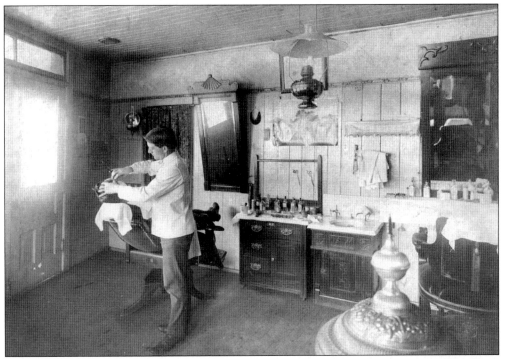

This was Schrader's Barber Shop located on Monroe on the east side across from what would become Gladstone's Shoe Store. Later the barber shop moved to First Street between Main Street and Norris Street.

The large building in the center of this picture is the Edison office. To the right is the first telephone office and Goodman's Feed Store. To the left was Walter O' Brien's Drug Store. The road is Michigan Avenue.

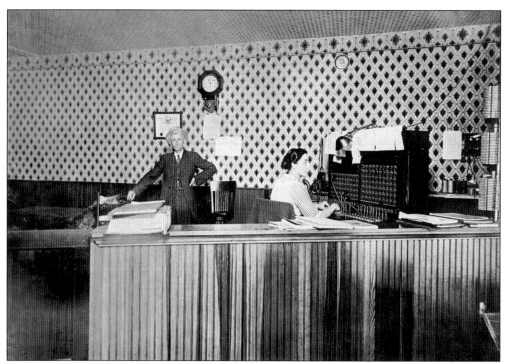

John Zeigler and Marie Fuller are seen here in the People's Telephone Company office c. 1915.

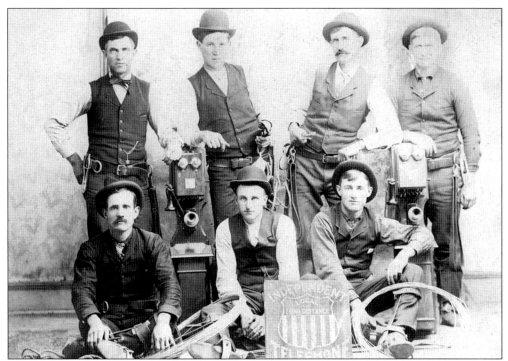

Joseph H. Coleman is on the far right in the front row in this picture of the Independent Long Distance Telephone company employees. The others are not identified. Telephones were a big thing in most communities. As soon as Wayne got one, the newspaper editor announced in large type that "Our town boasts a new telephone and it works like a charm."

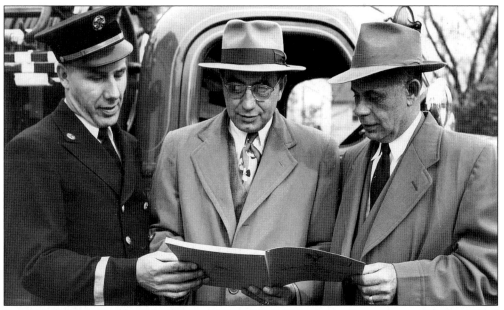

Fire Chief Hank Goudy, John McLaughlin of Bell Telephone Company, and Police Chief Larry Knox look at the first phone book in which emergency numbers were listed at the front of the directory.

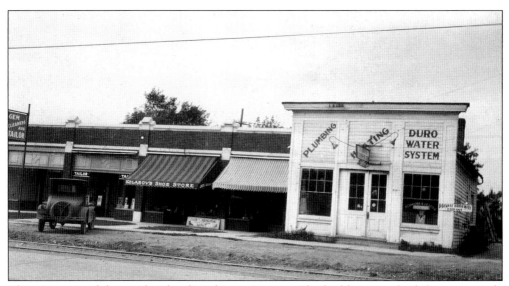

This picture is of the north side of Michigan Avenue. The buildings on the left are currently occupied by the Village Bar. At the time of the picture, there was Gem Cleaners and Tailor, Kolarov's Shoe Store, and the plumbing and heating business.

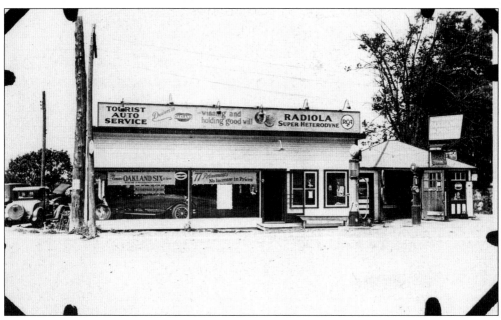

Morris Paddock Harris had a garage and Oakland and Pontiac dealership in the 1920s. This was just west of St. Mary's Cemetery.

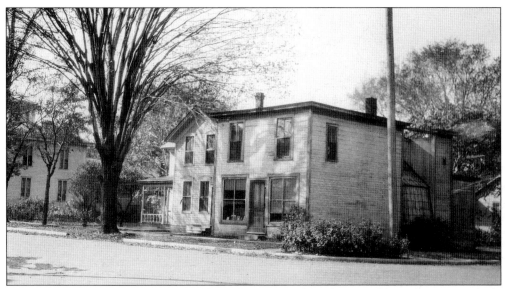

This was Susie Doolittle's Photo Gallery at the corner of Newberry and Norris. Susie Doolittle took over the photography business from her father and ran it for many years. She was involved with the Methodist Church, having been in the choir and serving as organist for the Epworth League and mid-week services. She was also Sunday School Librarian for many years. Susie was born here in 1865, and when she died in 1951, she was the Methodist Church's oldest member, having been a member for 75 years.

This is the southeast corner of Michigan Avenue and Second Street. The O'Brien house was across Second Street to the west. This was a popular store for the hunters and fishermen in the area.

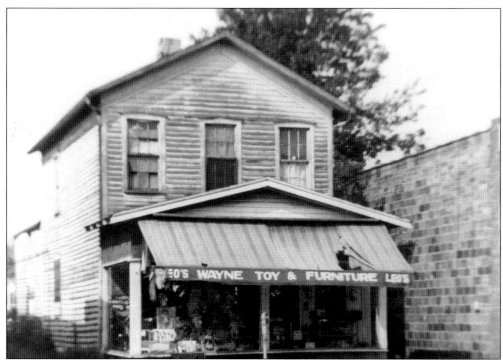

Leo's Wayne Toy and Furniture Store was located in the Newkirk house thought to be the first frame house in the town. It was approximately where Leo's Gift Shop is today.

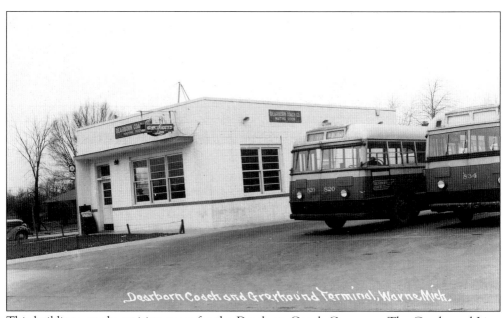

This building was the waiting room for the Dearborn Coach Company. The Greyhound Line shared the location. It was at Michigan Avenue and Laura.

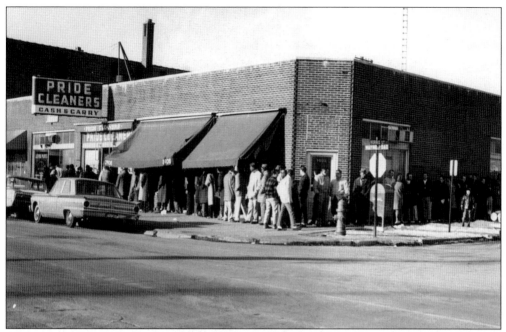

All license plates used to be renewed on the same date instead of on the owners birthday as they are today. Lines sometimes wrapped all the way around the block where the secretary of state's office was located. This office was on South Wayne Road at Norris.

The Wayne Dairy was a very special place. Not only did it provide milk for the community, there was inside this building an ice cream heaven. Some of the best malts and milk shakes in the world have come from this place. There was a list of concoctions on the wall that could challenge the best ice cream aficionado. One consisted of seven scoops of ice cream with various toppings, and if you could eat it all, you got another one free!

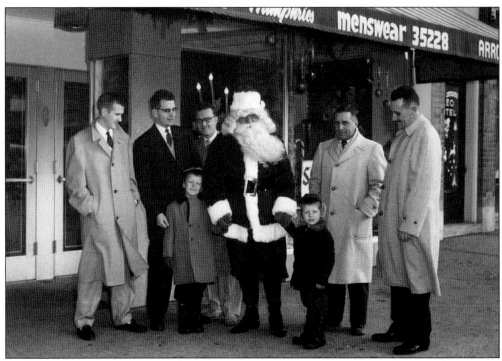

Businessmen in the community aspired to keep the family-friendly atmosphere. Here, with Santa Claus (Ted Thetford), are left to right, Ted McKinney, Milt Humphries, Walter Arvin, Dave Higgs, and Jack O'Brien. The children are unidentified.

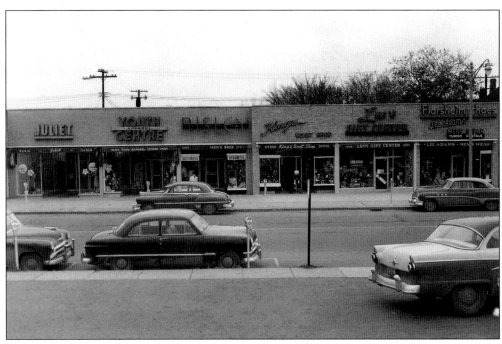

This view of the north side of Michigan Avenue east of Wayne Road had previously been the site of Leo Tooley's Ice Cream Parlor and one of Wayne's first "beer gardens" after prohibition.

Seven

COMMUNITY

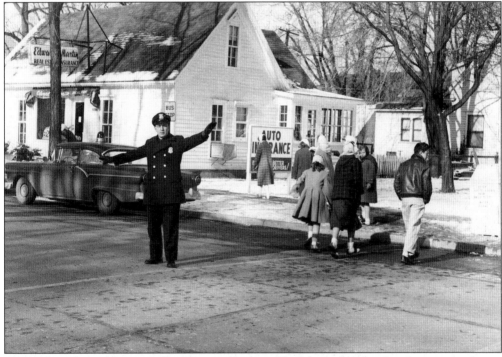

Wayne has always been a really great small town. But life used to be slower, everyone knew everyone—or at least was only one person removed from knowing someone. Churches, schools, and businesses all promoted an atmosphere of security. Values were taught at every turn, not in a dictatorial way, but by expectation. Individualism was often encouraged, but in the framework of appropriate respectful behavior. Opportunity was always there if you wanted it. There were as many problems facing Waynites as anywhere else, but there was also a lot of willingness to help. These next pictures are ones that define the area with its sense of community commitment. In the picture above, one of Wayne's police officers directs traffic at a school crossing. At this time officers also often walked a beat.

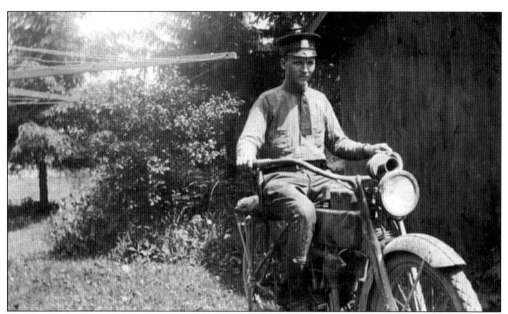

Many people don't know that Wayne once had a State Police Post. It was located at Howe Road facing east in the strip between east and westbound U.S. 12 (Michigan Avenue). This is Sgt. Frank Walker who was in charge of the post in 1921.

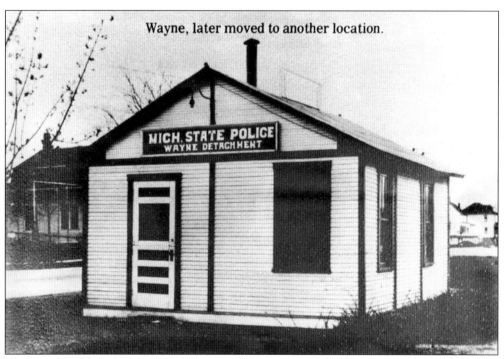

The actual building that served as the post was a very small wooden structure. When the post was moved, Jeff Smith took the building and moved it several hundred yards to use for his chicken coop. Photo courtesy of the Michigan State Police.

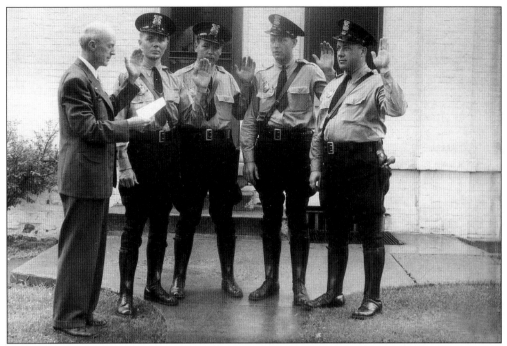

This picture taken in 1946 shows Clarence Ladd swearing in, from left to right, Harold Meldrum, Ed Harris, Melvin Whitney, and Hugh Robinson. Chief Larry Knox is visible in the doorway of the Village Hall.

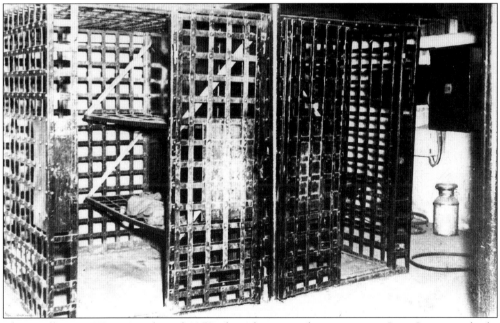

These cells were Wayne's jail until 1950 when the new police station on Sims Street was built. Stories told by some who should know claim that it wasn't unheard of to have as many as ten individuals in them on a Saturday night. A modern police station with gun range is scheduled to be completed in Wayne in 2005.

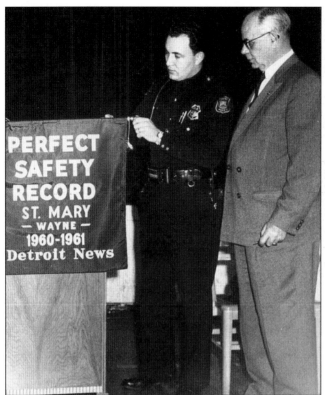

The community took an active role in safety education. This banner sponsored by the Detroit News and presented by Officer Ray LeCornu and Police Chief Larry Knox went to St. Mary's School for the 1960–1961 school year.

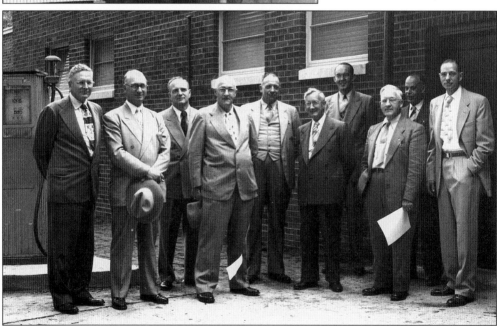

The new police building on Sims Street was inspected in June of 1950 by former Village President Dietrich, Village President McCormick, Councilman Weyand, Councilman Harrison, former Commissioner Attwood, Councilman Millar, Village Manager Arrowsmith, Councilman Moon, Police Chief Knox, and former Commissioner Stein.

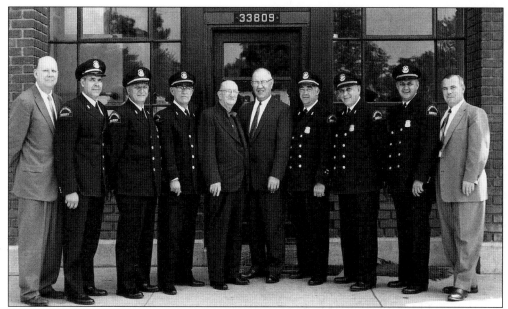

In addition to the State Police and the Wayne Police Department, Wayne also was home to an office of the Wayne County Sheriff. It was located at 33809 Michigan Avenue and was west of Howe Road. Shown here in front of the building are, left to right, Capt. Steve Derezinski, Lieut. Ronald LaRue, Lieut. Joseph Kopos, Capt. William Smith, Sheriff Andrew C. Baird, Inspector Paul Wencel, Lieut. Joseph Kovacs, Lieut. John Jankowski, Lieut. Dan D. Martin, and Capt. Gordon Traye.

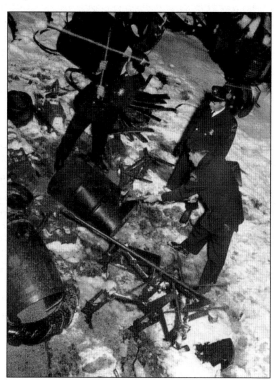

Here Wayne County Sheriff's Deputies are shown breaking up a still on Van Born Road.

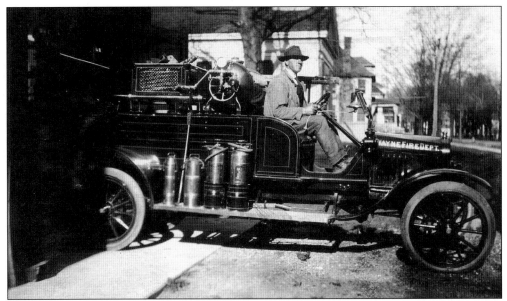

Fire Chief Charles Goudy (1874–1938) is seen driving the Model-T fire truck out of the station and onto Main Street in 1917. Charles Goudy's name pops up frequently in looking at Wayne history after 1900. He was a man for the community and in his career wore many hats. He was a section boss on the Michigan Central Railroad, had a coal yard on Michigan Avenue, and was Fire Chief, as well as Village Town Marshall, Superintendent of Public Works, Village Plumbing Inspector, Village Water Commissioner, Village Sewer Commissioner, Village Street Commissioner, Village Building Inspector, and he installed the first water main in 1914 and the first sanitary sewer in 1919.

This 1940 picture shows the side view of the Village Hall/Fire Station and the door where the fire truck was driven out onto Main Street. On the other side of the building was another garage where another fire truck exited. One was for the Village and the other was for Nankin Township.

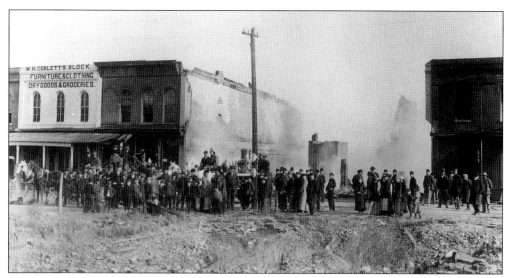

Some very large and destructive fires occurred in Wayne during its early years causing conflict between community leaders regarding the development of a fire department and the purchase of fire equipment. This fire necessitated a call to Detroit where fire equipment was put on the train and sent out the MCRR to the Wayne station. Teams of horses waited to convey the equipment to the site of the inferno. Although the trip was quick, only a little over an hour by one account, much damage had already been done, and the greatest benefit achieved was to prevent the spread of the fire to other buildings.

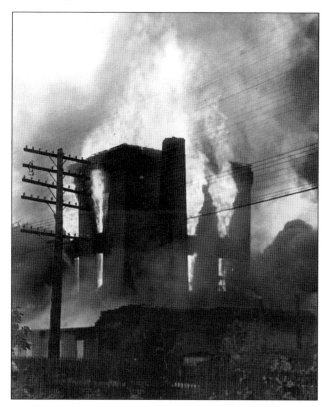

The Wayne gristmill fire in October of 1938 was a spectacular sight. Fire fighting had come a long way from the days when every able-bodied person lent a hand with the bucket brigade, but there was still a long way to go.

97

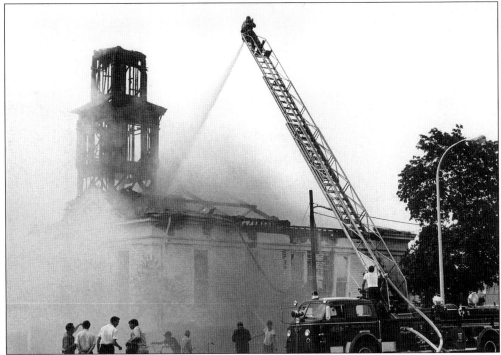

Even with the most modern fire fighting equipment and quick response, there was no saving the First Congregational Church that burned in August of 1970. The building was well over 100 years old and a favorite landmark in the community. The cause of the fire was thought to be painters who were attempting to remove old paint with a torch.

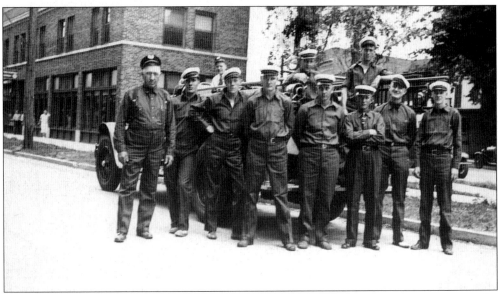

The Wayne Fire Department posed for a picture in 1932 when they were preparing to go to the Firemen's Field Day in Northville. From left to right are Fire Chief Charles Goudy, Hank Goudy (who later became Fire Chief), D. Doletzky, R. Janner, O. Prieskorn, R. Wardell, I. Reed, J. Vallance, and T. Doletzky. Standing on the fire truck are F. Houfley and W. Dittmar.

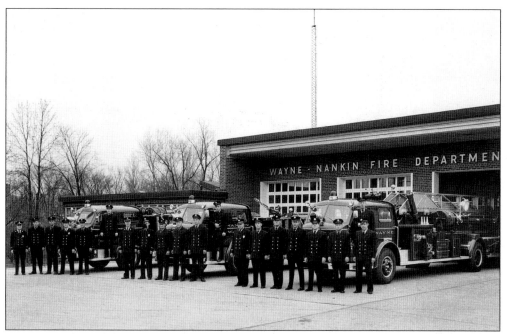

Firemen for the Wayne-Nankin Fire Department pose with fire trucks at the then new fire station on the west side of Wayne Road just north of the river. This building was torn down in 2002, and the new fire station is scheduled to open on the same site in the spring of 2004.

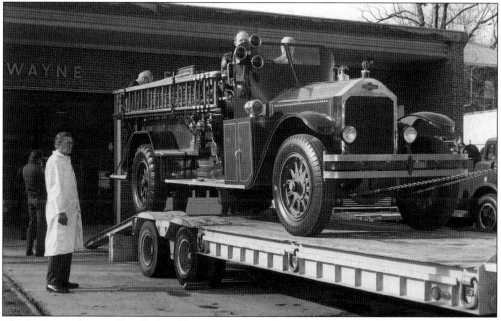

The LaFrance fire truck, called "Old Betsey," is seen here being loaded on a flatbed for the ride to Henry Ford's Greenfield Village in 1989. The fire truck was the second of Wayne's historic artifacts to be sent there. Henry Ford asked for and was given a small cannon that sat in front of the Village Hall. It has several times been relocated in the Village. "Old Betsey" came back home to Wayne in 2002. (Photograph courtesy of The Henry Ford Museum, Dearborn, Michigan.)

Charles Goudy, with a little help from an unidentified young man, sets the ground rules for the water fight about to take place.

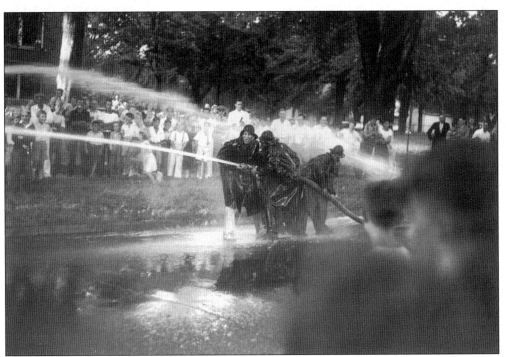

This water fight was a community event with everyone cheering on their favorite team.

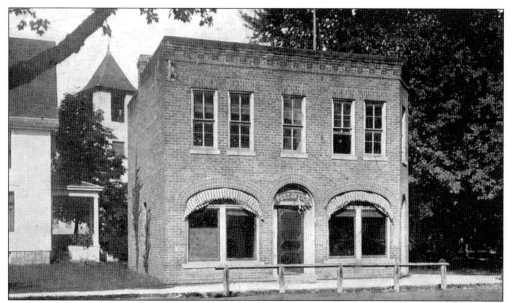

This was not Wayne's first post office, but it goes back to 1893 and remained the post office until 1919 when it was moved into the Masonic Temple. In the early days of the post office, it was located wherever it was convenient and there was space, such as in Morrison and John's Shoe Store. The first rural carrier out of Wayne was Civil War veteran Harvey Heywood.

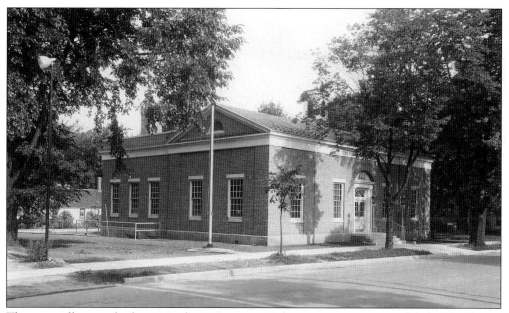

This post office was built on Newberry Street at Park in 1938. It was remodeled and enlarged in 1964. During the depression, artists from the WPA (Works Progress Administration) were sent around the country to paint murals in post office lobbies. Wayne's, which disappeared with the remodeling, was a pastoral scene with cows grazing behind a fence and a train with a steam locomotive pulling a train across the countryside. Postal patrons waiting their turn in line could often imagine themselves in that scene when the far away sounding train whistle from the Pere Marquette was heard.

Garbage disposal has always been an issue wherever people come together in a town. In the early days of Wayne, there was, of course, less disposable material. It was either burned or buried. Later, ordinances determined how disposal was to take place. There wasn't curbside pick up. Residents carted their unwanted items to the town dump. Like most other communities, Wayne had, over the years, a number of dump sites. This sign warns of a $100 fine for dumping where obviously dumping had already taken place. Directions are given to the new location. Seen in the background across Wayne Road is the Wayne Recreation Building, now the City Hall.

This sign gives clear directions to those on the way to the Wayne-Nankin dump site.

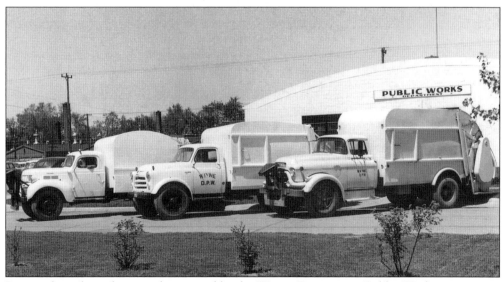

Progress brought garbage trucks manned by the Wayne Department Public Works.

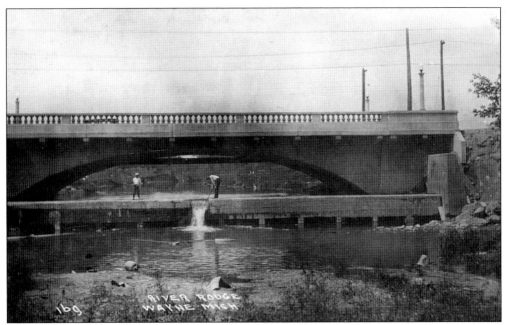

This is a view of the Wayne Road bridge from river level about 1926.

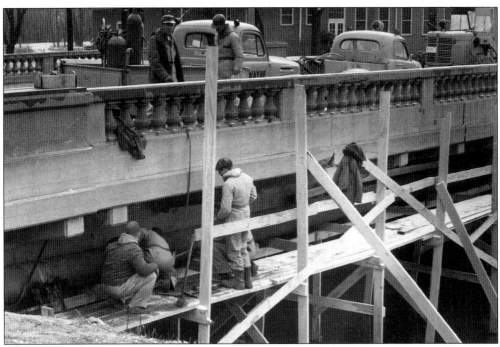

Here, Wayne Department of Public Works employees work to repair a pipe under the bridge. Council, administrators, and voters have directed the course of events in Wayne, but DPW employees have had the task of care giving and nurturing the community through broken water mains, road cave-ins, water works projects, storm damage, and other problems documented in hundreds of pictures saved over time.

The Wayne County Road Commission had a yard at Michigan Avenue and Howe Road for many years. These buildings were used to repair the trucks and other heavy equipment owned and used by the County to build and repair roads. Brick siding was added later. The buildings were eventually torn down to be replaced with the current engineering building. (The section in the middle was where the Sherriff's Department was located.)

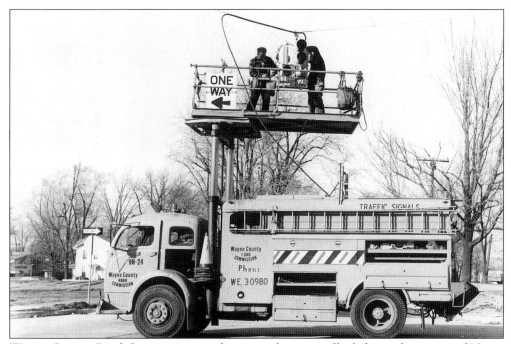

Wayne County Road Commission employees work on a traffic light at the corner of Norris (now Michigan Avenue east) and Sophia (now Elizabeth).

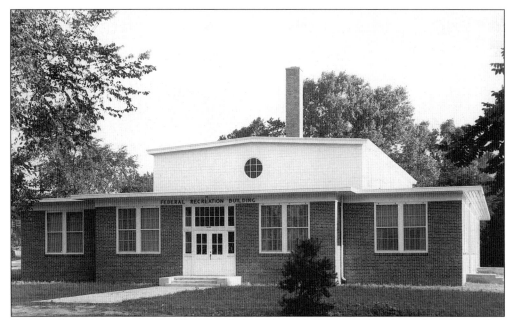

Wayne's Federal Recreation Building was dedicated in 1945. It was the place where kids roller-skated, had dance lessons, held dances and community plays, and was the site for the annual flower show, to list but a few uses to which this building was put. It is now serving as Wayne's City Hall.

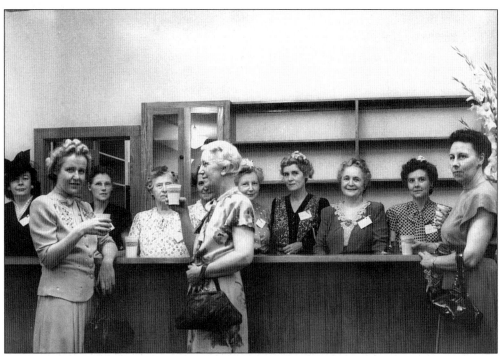

The dedication of the new recreation building was a big event in Wayne. From left to right behind the snack bar are Mrs. Lyle Hartman, Mrs. William Smith, Mrs. F.W. Hoops, Mrs. M.L. McCoy, Mrs. John Benjamin, Mrs. Al Walker, Mrs. Clarence Ladd, and Mrs. Robert Bird. In front are Mrs. Lois Hisey, Miss Ellen McMurtry, and Mrs. A.R. Kelley.

This picture of the Wayne Branch Library shows it on Newberry Street almost across from Susie Doolittle's photography studio. It was only in this location from 1927 to 1930. During its history, the library had started out as a reading room; had become the Ladies Library Association, meeting every Saturday from 3 to 5 p.m. over the Wayne Bank (in 1892); had been housed in cramped quarters in a shoe store; and had finally come into its own as a bona fide library.

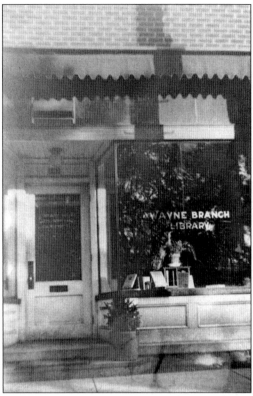

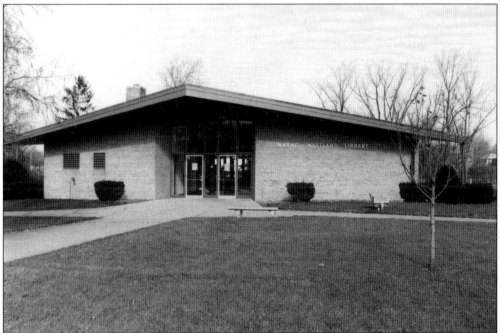

Wayne's library has undergone many changes. It has been a Wayne Branch Library, a Wayne-Nankin Library, a Wayne-Westland Library, and finally, in the1990s, Wayne and Westland each got their own libraries. The building pictured here is now the Senior Center.

Wayne had a very active YMCA. It was supported by community leaders and businessmen and was located in a house on Main Street. Pictured here, left to right, are Robert Ecklund, Duncan Millar, Keith Millar, and Clarence Woolf.

LIFE

FIRE DEPT.

A REDECLARATION OF INDEPENDENCE

Inside a suburban firehouse in Precinct 2, Nankin township, Wayne County, Mich. (*above*), and at thousands of other equally unprepossessing polling places the American voters last week redeclared their independence. The 60 million ballots they cast shattered all partisan bonds and all predictable patterns. Never in any presidential election had so many votes been cast for the loser—and never so many for the winner, Dwight D. Eisenhower.

The voters turned out to be not at all as they had been described by wiseacres, pollsters and politicians. The Southerners, Democratic to the third generation, were not solid. The immigrant sons of the north were not bound by partisan memory or inheritance. The minorities of the great cities were not delivered in bloc. The members of the labor unions were not bossed by their bosses, union or otherwise. Above all, the women were not willing just to go along. Behind polling booth curtains, individual Americans acted as individuals, responsive to the personal appeal of a great American and responsible only to themselves and to their consciences.

Nankin's Precinct 2 voted like the nation— overwhelmingly for Ike. When its votes were counted, the elation of victory was also sobered by a feeling of responsibility. A group of Nankin's Eisenhower workers gathered in the dining room of precinct leader Niram Hawley. On television they heard Adlai Stevenson plead graciously for national unity, then they saw their own candidate acknowledge victory. The crowd in New York, 600 miles away, began to sing. Niram Hawley probably didn't realize what he was doing. But there he stood staring at people on the television screen and softly chanting *The Battle Hymn of the Republic*.

By the 1950s, Wayne was recognized nationally as a community representative of the nation. (Photo courtesy of Joe Scherschel/TimeLife Pictures/Getty Images, Inc. Text in photo © 1952 TIME Inc., reprinted by permission.)

This wonderful Christmas fantasy land was located in the Park on the northwest corner of Biddle and Main Street. It was an example of the time and work service clubs put into the community. Santa's Workshop was in the building on the right.

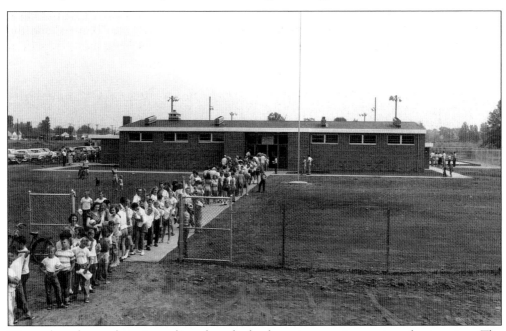

Wayne has always, from its earliest days, had a huge interest in sports and recreation. The community has supported a terrific recreation department, and this picture taken in the mid 1950s of kids lined up at the local pool tells the story of why.

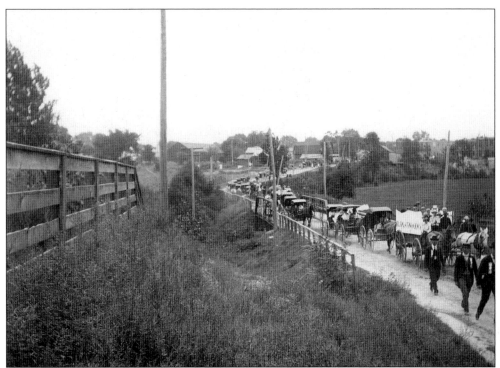

Wayne has a history of 4th of July celebrations that are noteworthy. The newspaper reported on one 4th of July that "The 'Glorious Fourth' began with the firing of anvils at 1:00 a.m.; ringing bells of the Methodist Church at 2:00 a.m. (a break-in); a demonstration by a mock band until morning. People gathered from the country, forming a procession to Charles Grove. Oration, music, dinner and in the afternoon, a ball game between the "Bruisers" and the "Merriman" Club." This picture is part of the 1900 4th of July parade being led by three Civil War veterans and followed by the Modern Woodmen of America.

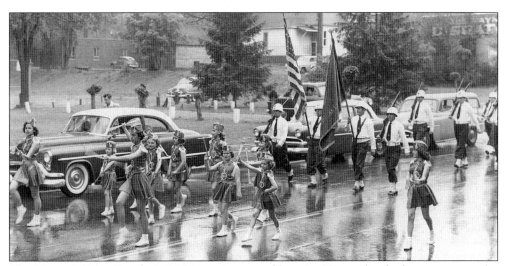

The Memorial Day Parade in 1955 wasn't stopped by rain. Wayne has had some spectacular parades.

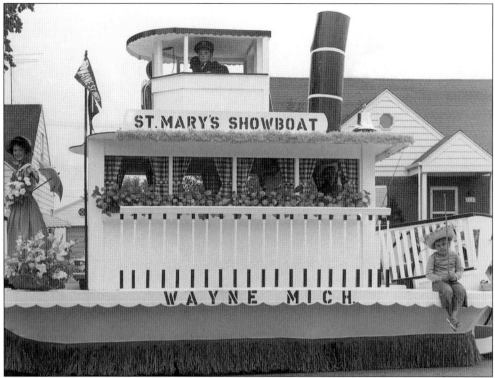

This was St. Mary's offering in the Fall Festival Parade in 1963.

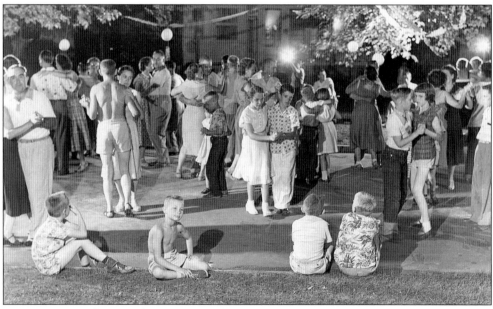

One of Wayne's longstanding events and renowned rivalries has had many manifestations. The Newberry-Biddle Street Feud has provided wonderful, funny, and happy images to record real community spirit. At the end of the day, the feud over "til next time," dancers celebrate their victories.

Eight

To Be or Not to Be

<div style="border:1px solid black; padding:1em;">

"DO YOU WANT YOUR AREA TO BE A PART OF THE PROPOSED NEW CITY OF WAYNE?"

Yes _____

No _____

Remarks: _____

Name _____

Address _____

</div>

The card above is the one that was sent out to area residents in 1953 to see how everyone was feeling about the city issue. Various possible boundaries had been discussed, and there was literally the issue of "to be or not to be" part of the city. Some of the responses for and against are listed here:

Yes: "Sanitary sewers badly needed . . . area is overrun with septic tanks." " . . . Definitely in the Palmer Road area east of Merriman." "We are ready for it and need it." "We need water and sewers. Also lights, police protection, and walks." "I hope sincerely that we get immediate service such as sewer lines and storm sewers and not in ten years!" One said, "Yes, provided I am not restricted from bringing my means and way of making my living and parking in front of my home." "Yes, if boundaries are Van Born Road, Joy Road, Hannan Road, and Merriman Road."

No: "We are on a farm. We already paid for all the conveniences we enjoy. Our taxes would be outrageous for being out so far from the heart of the city. We still want to farm—not be part of a city." "We would lose our freedom to do as we wish with our land. In time we'd have nothing but restrictions and taxes. No gain, only lose our country freedom." "I moved here to be in the country!" "Our taxes now are $106.00 a year, we have fire protection and I cannot see $53.00 more just for garbage pickup and dusting the road. . . . "

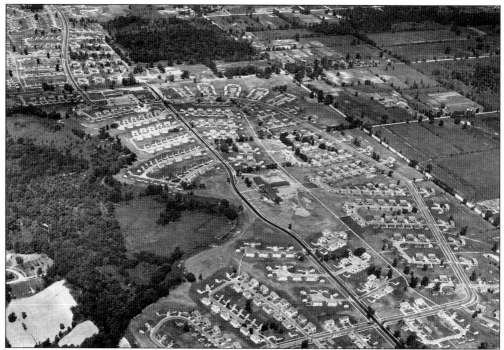

Norwayne had been built during the war, and various documents indicate it was meant to be permanent, others that is was not. The area managed much as its own community with a church, stores, and a community center. The issue of city hood made Norwayne a much contested area both for and against being brought into the city that was to be.

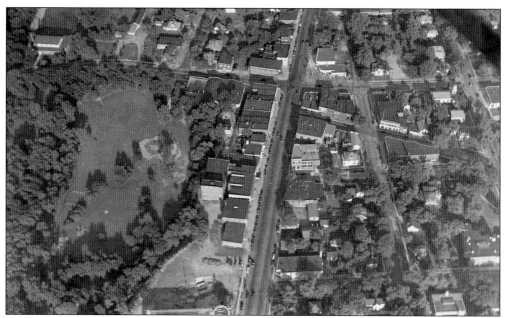

This aerial photo shows Michigan Avenue, dividing the photo in half. The State-Wayne Theater had been built, but the municipal parking lot hadn't yet been filled in and was, in fact, a baseball diamond.

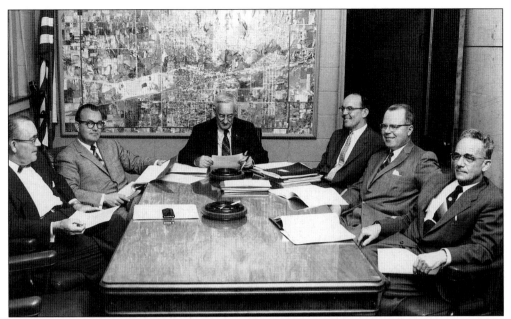

On the eve of city hood, the last meeting of the Village Council took place with, from left to right, George Smith, Charles Lents, Duncan Millar, Wallace Arrowsmith, Charles Curtiss, and Harold Hargrave attending. The meeting table is at the Wayne Historical Museum.

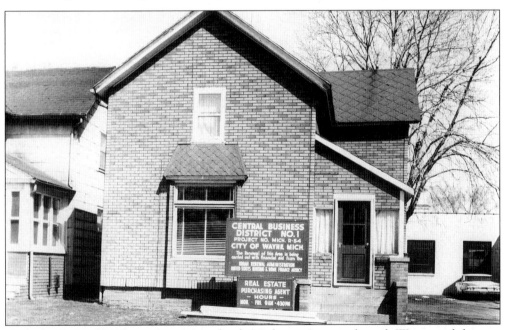

With the State of Michigan wanting to divide Michigan Avenue through Wayne and the new City wanting to move forward progressively, Urban Renewal was embraced with whole cooperation if not with whole heart. A city administrator who is relatively new to Wayne commented several years ago after attending a community event that if he did not know better he would think urban renewal was two or three years ago instead of over 30 because of the intensity of feeling still expressed by some of Wayne's older residents.

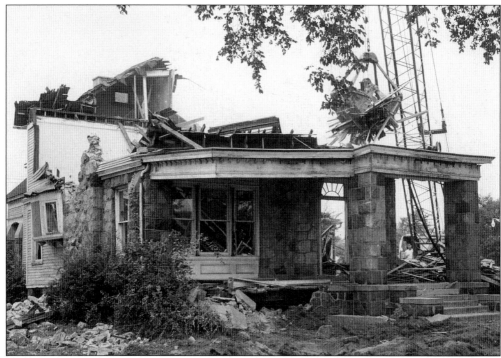

The Hosie house was one of Wayne's finest homes. It had served as a convent for St. Mary's Church and eventually as a sheltered workshop after being sold to the parish for a dollar by the Hosie family. (The Hosie family also gave $10,000 to the Wayne Historical Museum.)

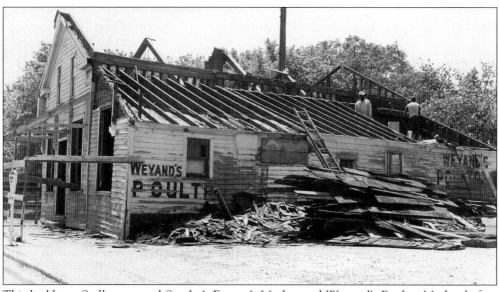

This had been Stellwagon and Snyder's Farmer's Market and Weyand's Poultry Market before it was torn down.

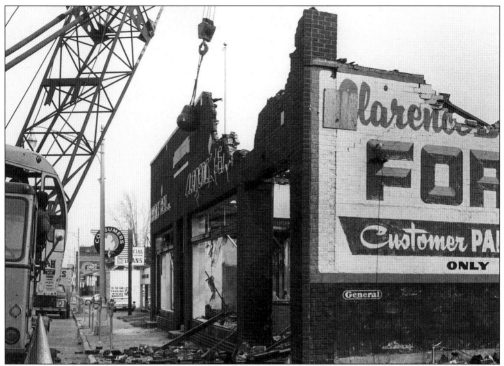

The wrecking ball knocks down a wall of the A.S. Poole building on the south side of Michigan Avenue between Newberry and Elizabeth. The last tenant had been Clarence Bell Ford.

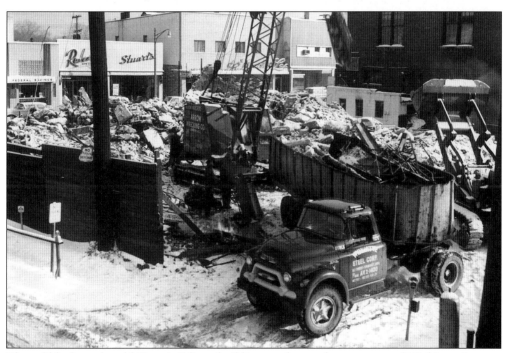

The rubble from the old Detroit Edison building on the southeast corner of Michigan Avenue and Biddle is being hauled away.

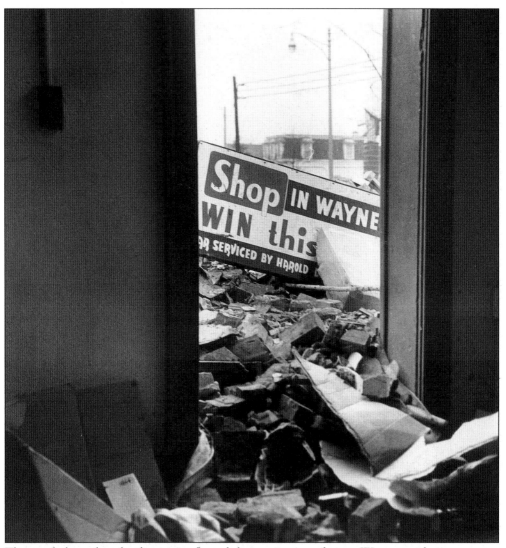

The words framed in the doorway reflected the sentiments of many Wayne residents.

This carnival on the flats (which were later filled in for parking and Wayne Towers) was always a much anticipated community event. It had sometimes been held west of the town where cars are now loaded onto trains at the Chesapeake and Seaboard Express yard.

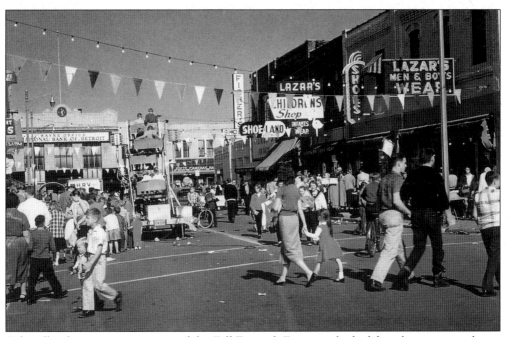

Sidewalk sales were a major part of the Fall Festival. Everyone looked for a bargain, merchants sold the items they didn't want to carry over into the next season, and it was a great reason to socialize. Cotton candy and street dances were also part of the celebration.

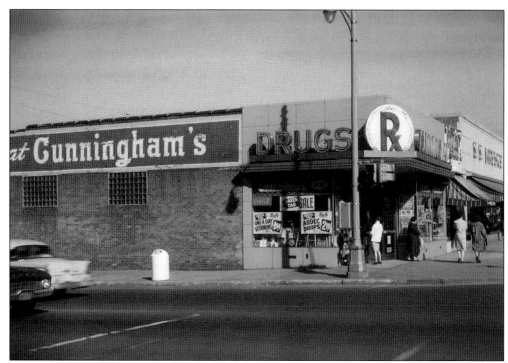

This view of the northeast corner of Wayne Road and Michigan Avenue had once been the site of the Varney House Hotel. Later it was Kroger's and Cunningham's. On the right is the S.S. Kresge Store.

Watson's Diner was on the south side of Michigan Avenue east of Third Street.

Eight
INDUSTRIAL HERITAGE

Charles Attwood is an example of the type of person who over its history put Wayne on the industrial map. In 1923, he founded Deceleco, Inc., in Detroit and moved the company to Wayne in 1926 where the company became Unistrut. He invented a method of fastening steel together without having to bore holes in the metal. Knowledgeable people have said that very few buildings have been constructed without Unistrut components. Attwood was generous, giving much of his fortune from the multimillion-dollar company to the U of M School of Architecture, the Congregational Church, the Wayne Recreation department, and countless other causes he thought deserving.

Unistrut located on Wayne Road south of the railroad.

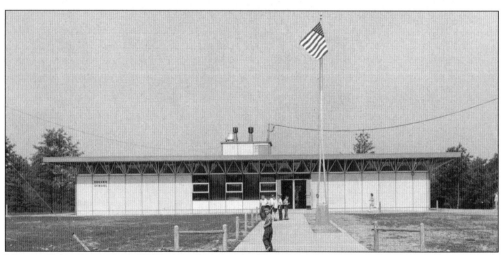

Hoover School was one of Wayne's Unistrut buildings.

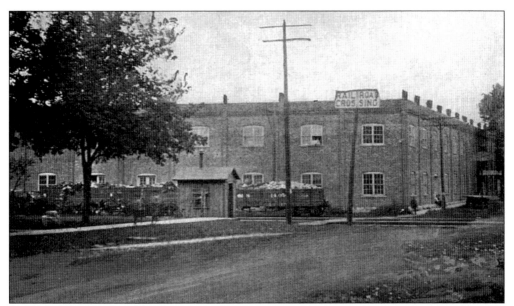

Prouty and Glass Carriage Company was on Sophia (Elizabeth) just north of the MCRR tracks. It was the largest manufacturer of cutters in the United States, manufacturing 6202 cutters and 3300 buggies in 1899.

Enot Foundry was organized in 1920. The first castings were made in 1921. There were approximately 70 employees, and it took 22 hours to produce one day's production of castings. The foundry was on the northeast corner of Annapolis at the Pere Marquette (CSX) railway. Castings were made for cars, trucks, marine engines, refrigerators, washing machines, conveyor parts, office equipment, and much more.

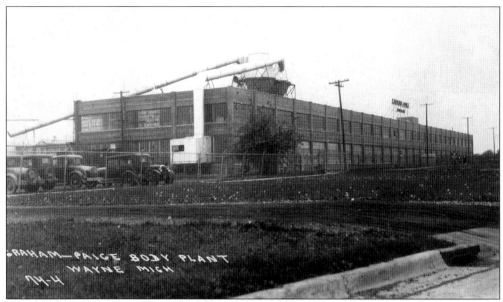

Graham-Paige cars were manufactured in Wayne. This is the factory, still standing on the south side of Michigan Avenue at the railroad. It has changed over the years to accommodate numerous manufacturers, but from 1927 when it was bought from the Gotfredson Company (who had purchased it in 1924 from Harroun Motors), it served as the Graham-Paige factory. During WWII, it was sold to the government and continued as Bendix Corporation, manufacturers of airplane parts.

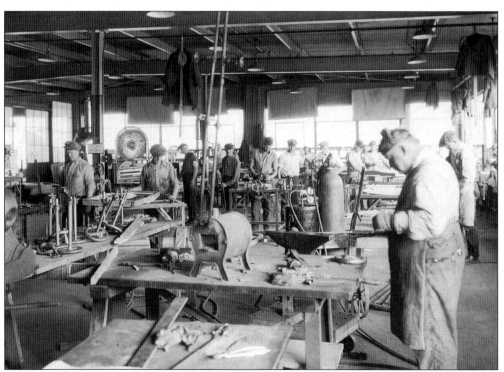

These unidentified men are employed in the Graham-Paige factory.

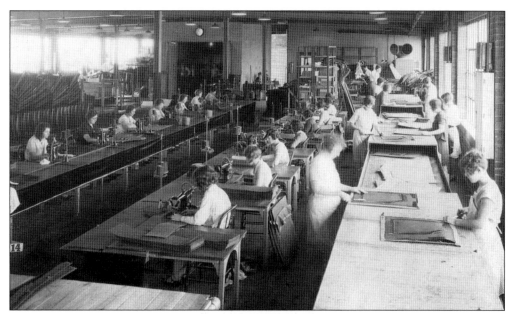

Many women were employed by Graham-Paige as seamstresses. Pictured in 1928, from the lower left and continuing up the rows, are Zina Miller, Lou Birch, Violet Bowers, Adell Levitz, Margaret Moore, Edna Coleman, Nellie Benedict, Virginia Wurm, Helen O'Bryant, Mary Kotoski, Esther Strawn, Etta, Tonkins, Daisy McCann, Genevieve Gardner, Dolores Derosia, Rose Olzack, Ann Dalia, Marie Benedict, Linnie Boyd, Alice ?, Irene Kuhn, Helen Mace, and Mildred Van DeCar.

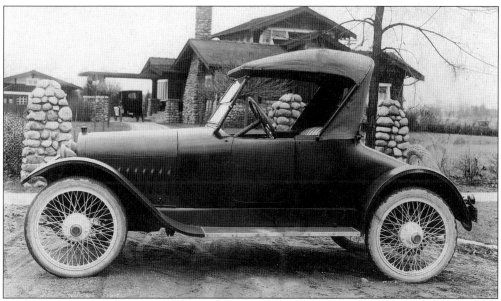

The Harroun Motor Car was manufactured in Wayne in a factory bought from the Prouty and Glass Company (the factory at the railroad was built but never used by Prouty and Glass because the automobile put them out of business). It was named after Ray Harroun, the winner of the first Indianapolis 500. When WWI started, they were given a contract to manufacture shells for the military. When they tried to return to auto manufacturing after the war, they were not successful.

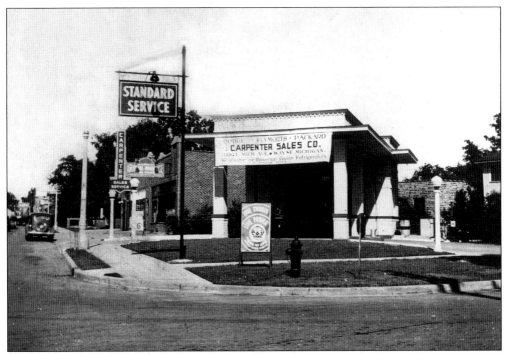

Wayne has had many auto dealers over the years. Carpenter Dodge, Plymouth and Packard sales and service was on the northwest corner of Michigan Avenue and Second Street where One Hour Martinizing is now.

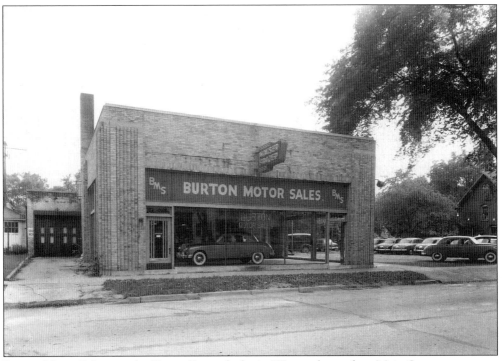

Burton Motor Sales was the Kaiser-Frazer dealer in Wayne, located on Main Street.

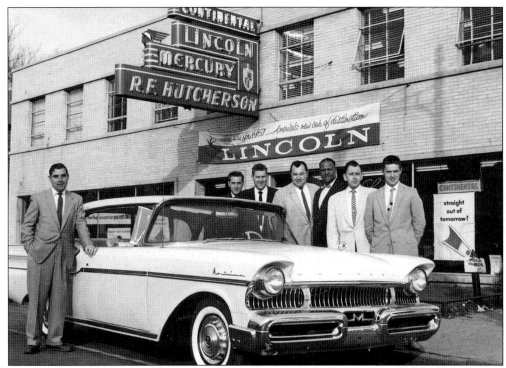

R.F. Hutcherson was on the north side of Michigan Avenue between Sophia and Elizabeth.

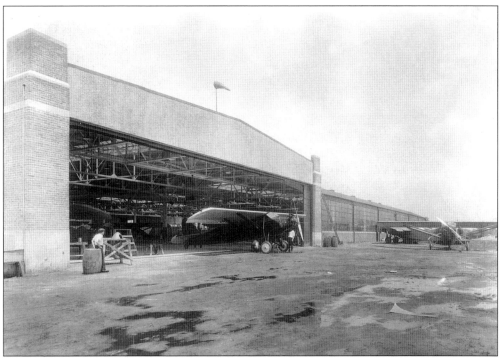

Stinson Aircraft was considered a Wayne manufacturer and had a Wayne address even though the physical plant was on the Romulus Township side of Van Born Road.

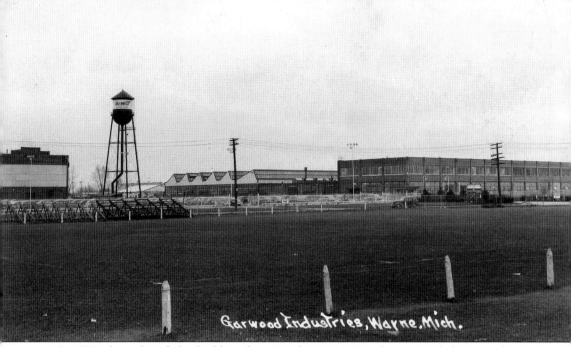

Garwood Industries, Wayne, Mich.

Gar Wood purchased the building from Bendix in 1946 and continued there until moving operations to Van Born and Venoy Roads. They built and shipped around the world their "load-packer refuse collection vehicles." Gar Wood had pioneered the hydraulic hoist for dump trucks in 1912. They built the world's largest ditcher of the era, *c.* 1951, costing $100,000.

Wayne has had many industries, including some almost forgotten. There were cigar manufacturers, a toy company, and the J. Kimball Arms Co., which manufactured automatic pistols. There had been a knitting company, a canning company, and a novelty works. Steering wheels—large metal and wood ones—were manufactured in Wayne as were brooms and commercial toasters. Musical instruments were made. Wayne has had its share of inventors, too.

In 1958, Wayne was called an Industrial Giant.